# EFFECTS AND TRICKS

# EFFECTS AND TRICKS

## PAINTING

# LANDSCAPES

## AND ATMOSPHERE

### JOSÉ M. PARRAMÓN

Overall manager: José M. Parramón Vilasaló
Texts: José M. Parramón and Gabriel Martin
Editing, layout and design: Lema Publications, S.L.
Cover: Lema Publications, S.L.
Editorial manager: José M. Parramón Homs
Editor: Eva Mª Durán
Original title: Pintando al óleo
Translation: Mike Roberts
Coordination: Eduardo Hernández

Photography and photosetting: Novasis, S.A.L.

First edition: April 2000
© José M. Parramón Vilasaló
© Exclusive publishing rights: Lema Publications, S.L.
Published and distributed by Lema Publications, S.L.
Gran Via de les Corts Catalanes, 8-10, 1º 5ª A
08902 L'Hospitalet de Llobregat (Barcelona)

ISBN 84-95323-34-6
Printed in Spain

# Table of contents

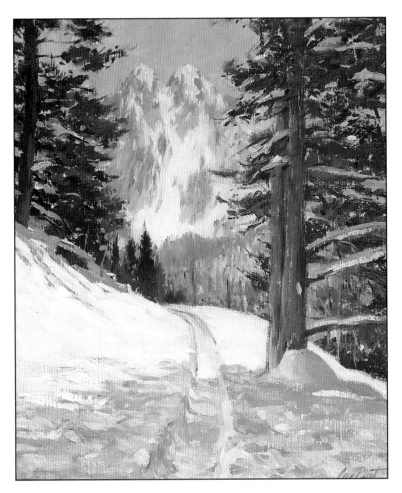

**Introduction, 6**

Climatology in painting, 8
The colors of a landscape, 10
Depth and atmosphere, 12
The photograph as a support, 14
Interpretation, the key factor, 15
The summer sun: a landscape with intense light, 16
The winter sun: a landscape with diffused light, 20
A sunset, 24
A sunrise, 28
Fog in a landscape, 32
Desert climate, 36
Showers of rain, 38
Rain in the city, 42
Lightning, 46
After a storm, 48
How to represent the wind, 52
Ice: a frosty landscape, 54
Snow, 56
Painting a snowstorm, 60

**Glossary, 62**

**Acknowledgements, 64**

**1**

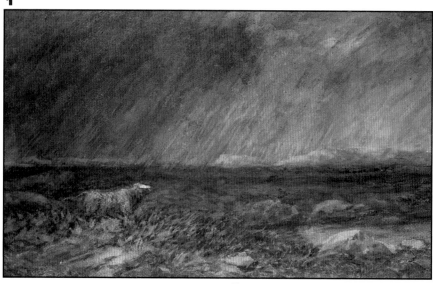

To get a better understanding of the influence of the sky on a landscape, you need only to look at the surface of the sea. You will notice that its color depends enormously on the color of the sky that it reflects. On a gray, overcast day, the sea will also take on a grayish appearance, whilst on a bright, sunny day, the sun will spread shining blues and turquoise greens across its surface. When painting a landscape, it can often be difficult to capture certain meteorological conditions on canvas or paper because of their fleeting nature. However, given that changing atmospheric conditions so often determine the general character of a landscape, it

**2**

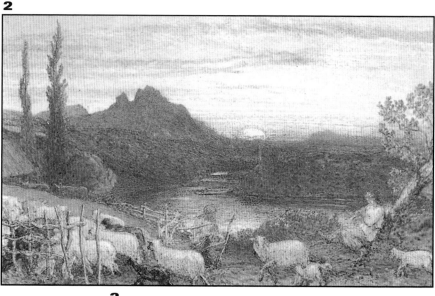

If the planet Earth were not surrounded by a layer of gas, there would be no life upon it. On this protective layer of oxygen and nitrogen, each of the planet's meteorological phenomena also develop, the expressive forms of the sea of air range from the softest of breezes to thunderous storms that transform and even damage the landscape. Much of the pleasure and emotion that a landscape painting provokes in the spectator is derived from the observation of different transitory climatic effects, and the colors and lights that a landscape adopts under such changing conditions at different times of the day and during different seasons. A landscape is therefore dependent on the changing state of the sky, which plays a leading role in this story. It acts as a huge sheet of colored glass that inundates everything with its light and determines the colors of a landscape.

*Figs. 1 to 4. The light that illuminates nature throughout the months of the year and at different times of the day, rain, snow and clouds... in other words, the meteorological changes that come with the different seasons, are among the most significant factors when it comes to perceiving and interpreting a landscape Look at these examples: a storm in* The challenge *by Arguably Cox (Victoria & Albert Museum) (fig. 1); a sunset in* Going to Fold *by John Linnell (Victoria & Albert Museum) (fig. 2); a snowfall in* Paris beneath the snow *by Paul Gauguin (Rijksmuseum Vincent van Gogh, Amsterdam) (fig. 3); a cloudy day in* Old Sarum *by John Constable (Victoria & Albert Museum) (fig. 4).*

**3**

# Introduction

is important that these characteristics are considered and dealt with as an integral feature of the composition. Not only do meteorological conditions generate transitory effects on a landscape, but they also give it a new spirit and put new meanings into nature, so that all that suggests immobility, stability, gravity, density and solidity is blended into the liquid and impalpable forms of wind, light and atmosphere. But not everything boils down to the atmospheric conditions caused by the wind and rain, we must also consider light at different times of the day, such as at dawn and at dusk, and the way that light changes as the seasons pass by, even when the weather conditions are theoretically the same. A summer sun shines differently to a winter one. In the summer it shines more directly, whilst in winter its light is somewhat more diffused.

To get the right idea of each of these phenomena, it is a good idea to go out into the country and study them at close quarters, maybe using a notebook or making a few small, color sketches with fresh paint. Painting outdoors can be very rewarding; you feel a sense of being at one with nature and its elements. After spending some time practicing, you will not only notice the colors, forms and textures that surround you, but also the sound of the wind, of storms, of water and the smells of damp grass, of flowers and of corn baking under the sun. All of this will certainly help and inspire you as you paint.

In order to portray the different natural phenomena it is vital that you have a base and know how to transfer each of these weather conditions to canvas, as well as knowing the tricks that are used to represent such invisible and abstract elements as the wind. In this book, we shall show you how to paint the forces of nature in landscapes and teach you to understand how each of these climatic states influences the final appearance of a painting. We will be showing you how to represent the effects of a storm, lightning, falling snow or fog over the countryside. All of this with the assistance of professional artists. With a desire to paint and constant practice you will soon be picking up the skills and mastery that are needed for painting the many themes within the infinity of possibilities that nature produces over the length of a year.

**Gabriel Martín Roig**
Art critic

**4**

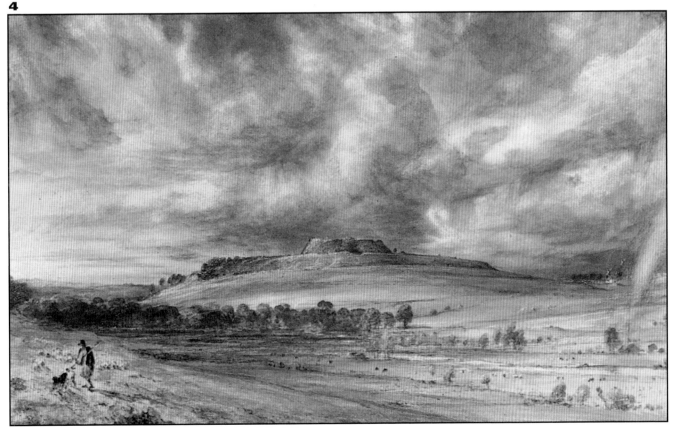

# Climatology in painting

The representation of meteorological conditions in landscape mattered little to the Renaissance painters. It was not until the Baroque period that artists really started tackling the subject. The Dutch Baroque painters and the British natural watercolorists were the masters of portraying climate in landscapes. Both groups painted stormy skies, covered by dark stormclouds that paled the bright colors of a landscape. Jan van Goyen's paintings represented the first step in translating into human emotions the hidden feelings that any patient observer finds in nature and the bright colors of a landscape. This feeling that started with Van Goyen's work soon spread to many of his contemporaries: Jacob van Ruysdael, Roland Roeghman and Aert van der Neert, who specialized in the fleeting and instantaneous painting of sunsets and moonlit nightscapes. These artists were characterized by the use of panoramic views, based on wide horizons, light patterns and spectacularly clouded skies, in accordance with the typical changes of weather in that region.

In the North of Europe the weather is far less stable than in the South, with its bright, sunny Mediterranean skies. This probably explains why there seemed to be a far stronger interest in depicting the weather in that vast geographical area. The unstable, dark Nordic Winters provoked wild passions and tragic sentiments in those who contemplated them. So it is not hard to imagine why those tempestuous skies were such common themes among the Romantic artists of the 19th century, artists that were deeply attracted to the grandiose violence that nature could throw upon us.

The forces of nature allow the artist to let his imagination run free and to transform his landscape into beautiful, expressive and dynamic forms.

Melancholy, irrationality, individual eccentricity

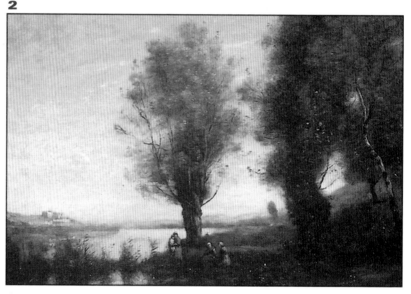

*Fig. 1.* The windmill at Wijk *by Jacob van Ruysdael (Rijksmuseum, Amsterdam). Notice the monumental character with which the artist portrays nature, particularly in the sky covered with clouds.*

*Fig. 2.* A morning. Dance of the nymphs *by Camille Corot (Orsay Museum). The dawn light inundates the landscape, creating a specific range of harmonious colors.*

and a desire to be at one with the forces of nature inspired the landscape artists of the Romantic period to portray the ways in which atmospheric phenomena affected a landscape. One of the leading exponents of this movement and passion for nature was the German Caspar David Friedrich. Paintings such as *Traveler next to a foggy sea* or *Hope within the ice*, are able to suggest the existence of a superior force, of a divine presence that captures the spirit, and allows man to discover his own

personal tragedy through the tragedy of a landscape.

For William Turner, nature became the motive for splendid visions that give way to something quite exceptional. His landscapes, with nightfalls shrouded in fantasy, storm-devastated fields and seas that bathe under the light of golden suns, are fluid and transparent, able to capture the images of the infinite patterns of light that different weather conditions can create.

The synthesis between the romantic vision of the landscape and the prelude to impressionism can be found in the work of the Barbizon school. This was formed by a group of artists that

neglected the hustle and bustle of cities in search of the calmness of nature. This deep sense of reality, portrayed with detailed realism, led to landscapes that showed a clear interest in atmospheric features. In this school we find Paul Huet, Camille Corot, Jules Dupré and Constant Troyon, among others. Their way of dealing with landscapes would have a strong influence on the work of Claude Monet, whereby light is transformed as the days and seasons go by, and clearly dominates the representation of nature.

**4**

**5**

*Fig. 3.* View of Naarden *by Jacob Ruysdael (Thyssen-Bornemisza Museum, Madrid). The interest in portraying panoramas and climate defines the content of this painting, in which the wintry landscape triumphs over any other factor.*

*Fig. 4.* The magpie *by Claude Monet (Orsay Museum). Frosty and snowy landscapes form part of this artist's vision of winter coldness.*

*Fig. 5.* Hope *by Caspar David Friedrich (Kunsthalle, Hamburg). Nature in Romanticism, often barren of human presence, is interesting as a mirror of a divine, mysterious, impenetrable and intimate presence that exaggerates the sensitivity of the spectacle that it offers.*

# The colors of a landscape

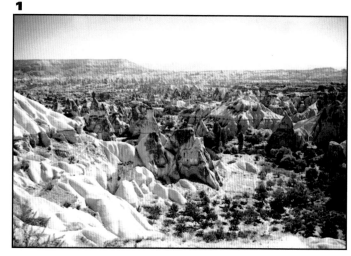

One of the most important aspects of a landscape is its color. Its emotive capabilities are able to stimulate not just our eyes, but our feelings too. Color can be used to suggest or accentuate the character of a picture, and can build emotions within the spectator's mind. The changing features of the weather have direct repercussions on the use of color and consequently upon the chromatic harmony of a piece. This can be seen on any stormy day, when rain takes the place of the sun and alters the way that colors react to each other and the tonal balance of a scene. The same is true of any sunset with the orange and violet colors that it throws across the landscape.

When painting a landscape under any specific meteorological conditions, try to settle on just one determined chromatic tendency. Clearly, if you are painting a snowy scene, your colors should be cool, with a dominance of blues, greens and violets. At dawn, when the landscape is submerged under a morning mist, grays and blues should be your basic colors. This is because diffused light weakens the strength and intensity of colors, making them seem more harmonious. On a cloudy or rainy day, there is a clear tendency to opt for neutral, gray colors. On a bright, sunny day, you should make ample use of warm colors such as

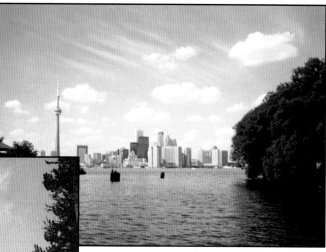

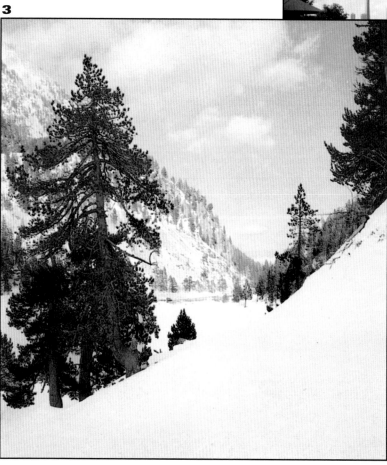

*Figs. 1 to 6. These different landscapes show different times of the day and different weather conditions. Notice how the chromatic harmony of each one falls within a specific range of colors: landscape of Göreme in Turkey on a sunny day. The dominant colors are yellows and ochres with a definite blue tendency as the image moves into the distance (fig. 1); view of the city of Toronto (Canada). Here the presence of the lake provokes a dominate range of blue colors (fig. 2); a landscape like this snowy valley in the Catalan Pyrenees (Spain) should be painted with discreet con-*

yellows, light greens and ochres. As the colors are brighter and more intense they will contrast with each other more clearly and lend the image a more dramatic character.

You will notice that at certain times of day and when subjected to specific atmospheric conditions, colors that normally contrast can appear to be in harmony. Harmony is possibly the most subtle and evocative of all of the relationships between colors, and it can be used effectively to put character into your paintings.

Therefore, when an artist faces the challenge of painting a landscape, the first thing that he should do is recognize the innate nature each of these chromatic tendencies and accentuate them, if necessary, to harmonize his colors better. This implies organizing the colors on our palette in order to get the ranges of colors that are needed in each case.

Although harmonious relationships are the most pleasant and easiest to achieve in a painting, try to avoid a monotony of pale colors when you paint. Variety of tone and intensity avoid this, because this puts the emphasis on a pattern of colors that dominates the whole through the provocation of light contrasts.

**4**

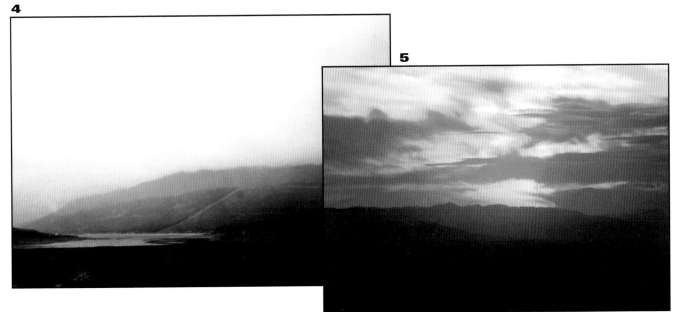

**5**

**6**

*trasts of blues, ochre-blues and violet (fig. 3); in this view of Loch Ness (Scotland) with its thick mist there is clear dominance of grays (fig. 4); quite the contrary to this sunset over the Pyrenees, with warm reds and yellows that make the sky look like it is ablaze with flames (fig. 5); early in the morning colors tend to look paler and only the intensity of sunlight is able to make the colors more vibrant. You can see this in this view of Salzburg, Austria, at sunrise. (fig. 6).*

# Depth and atmosphere

An important element in painting a landscape realistically is knowing how to represent a sense of the third dimension. As well as perspective itself, which is much more useful in urban than rural landscapes, one of the most common ways of showing depth in a landscape is recreating interposed atmosphere. This is the optical illusion that is caused by water vapor and particles of dust in the air that slightly darken colors and forms in the distance. In his book *The system of the arts* the philosopher Hegel puts it in the following way: "In the real world, every object undergoes a change of color as a result of the atmospheric air that surrounds it. (...) The further away an object is, the more discolored it will appear, and its form will be more indeterminate, because opposing lights and shadows start merging together". Therefore, as planes get further and further away, their colors are paler and have more blue, gray and violet tendencies.

Another of the classic ways of representing depth involves painting a foreground that can be compared in terms of distance and size with the main subject of the painting, which is situated a little further away. We instinctively compare the size of the subject with

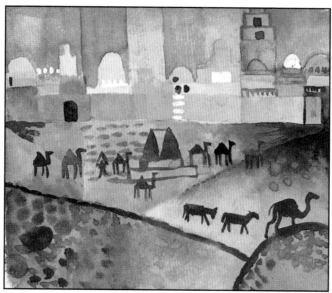

*Fig. 1.* Snow in Louveciennes *by Alfred Sisley. (Orsay Museum, Paris) Here is a clear example of linear perspective being used to create a sense of depth.*

*Fig. 2.* Kairouan *by August Macke (Staatsgalerie Moderner Kunst, Munich). See how strongly the German artist has used the "coulisse" effect in this watercolor.*

*Fig. 3.* Cornfield *by Ramon Martí Alsina (Museum of Modern Art, Barcelona). By including a contrasted foreground, along with the trees and figures that the artist has added, the illusion of depth and distance in this painting is far clearer.*

that of the more distant planes, particularly when it has a recognizable size, as is the case of an animal or a human figure. If there are no references in the foreground, you could use the idea that was so popular amongst the English painters of the 18th century, who represented the third dimension by painting a foreground with abstract, unfocussed and blurred forms.

The *coulisse* effect, in other words, the superimposition of planes, like the backdrops and scenery of a theater, is another formula for representing depth and the third dimension. Here the effect of depth is achieved by superimposing successive planes, although this idea is not advisable if you are painting landscapes with rain, mist or diffused light. The *coulisse* effect is more appropriate for sunny landscapes, when each different plane seems more defined and clearly outlined.

Depth can also be accentuated by using near and distant colors. It is widely understood that near or warm colors (ochres, yellows, reds) are colors that tend to be close to the spectator, while distant or cool colors (blues, greens, violets) tend to appear further away in the background. This phenomenon can be applied in painting terms to the warm tones and colors of a foreground and the cool colors and soft tones that make the background seem more distant. By putting this theory into practice, the effect of depth greatly enhances the sense of three-dimensional space in a picture.

**4**

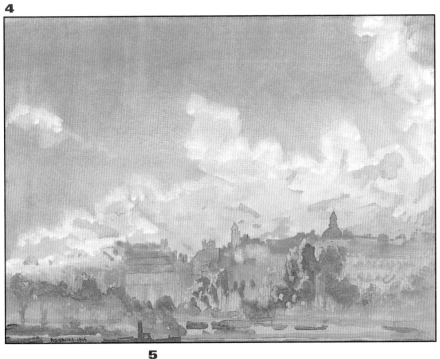

**5**

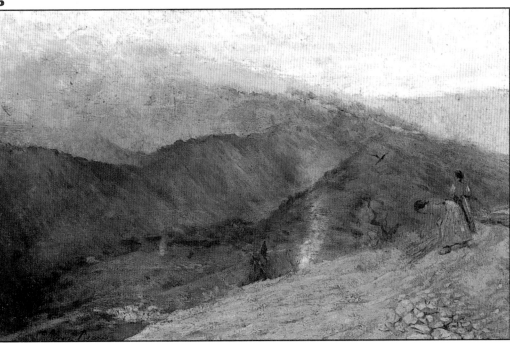

*Fig. 4.* **From Orleans dock** *by* **Arthur B. Davies (Brooklyn Museum). Notice how the foreground, nearer to the spectator, was painted with warm colors, while the silhouettes of the buildings and the other more distant elements were painted with far cooler colors.**

*Fig. 5.* **The mountains of Málaga** *by Pablo Ruiz Picasso (private collection).* **The interposed atmosphere can be seen clearly if we compare the foreground to the mountains in the background, which is full of blue and violet colors that seem to fade into the distance.**

# The photograph as a support

Painting meteorological effects in a landscape can be extremely interesting, but it can be difficult to do this from nature because conditions can change so quickly. This is where photography can be a useful aid.

A photograph should be used as an auxiliary tool and not as a goal in itself, because it usually far more beneficial to work from sketches taken from nature than a photograph. But photography can be justified in some cases, for instance when the weather makes it impossible to paint a decent picture: extreme temperatures, a heavy snowstorm, a sandstorm, a violent wind or any other such conditions in which it simply would not be feasible to paint a picture outdoors.

However, there are certain inconveniences to using photos. As it freezes a moment in time, there are certain phenomena that the lens of a camera finds extremely difficult to pick up, such as tenuous drizzle of rain, a soft breeze, or even a strong wind. To do this you need to photograph the effects that such conditions cause to the landscape, such as trying to photograph rain as it lands on the surface of a pond or wind blowing strongly through the branches of a tree. To take good photographs you do not need professional quality materials, just a simple reflex type and preferably manual camera with a simple lens. You should also have a small automatic camera ready for use on any occasion, because many intense snowfalls and showers can begin with little or no warning.

**1**

*Fig. 1. You should always have a small archive of photographs so that you always have suitable models in your studio for those days when you can't work outside because of the weather.*

# Interpretation, the key factor

Interpreting means change. It is taken as read that a true artist, when faced with a model or landscape, feels a need to transform or adapt it according to his needs, even modifying reality rather than just aiming for a purely photographic transcription. In the words of Paul Gaughin himself: "An artist has the right to deform, when

such deformations are expressive and beautiful. Nature is given to him so that he can print his own soul upon it, so that he can reveal to us the feelings that he has discovered in it".

This means that along with rational construction, one should also express fresh impressions, forgetting the mechanics that intelligence might impose and coming into contact with the direct spontaneity of nature.

The ability to change, modify and interpret is extremely useful when it comes to painting landscapes with particular weather features. This is particularly true of painting wind and rain, meteorological elements that are often unseen in landscapes, although their effects certainly are: wet streets, puddles, or the branches of tree bending violently. This is when your interpretative and inventive skills need to be put into practice, by creating effects in your paintings that suggest wind and rain (marking with the tip of a spatula, blurring certain outlines, painting directional lines, exaggerating the bends in the trees or making leaves take to the air).

Just one warning. If you want to represent wind, rain, fog or snow, let it be the painting medium itself that suggests it graphically and symbolically, or try to insinuate climatic effects. Avoid the use of kinetic lines, they are common enough in comics and cartoons, but do not work very well in paintings.

*Figs. 1 to 3. The ability to see other forms and colors, and to represent a different idea to that suggested by reality makes interpretation a key factor in the representation of a landscape. Here are some examples: The blue trees by Paul Gauguin (Ordrupgaard collection, Charlottenlund) (fig. 1); Houses in Arán by Óscar Sanchís (artist's private collection) (fig. 2); The port of Saint Tropez by Paul Signac (private collection, Paris) (fig. 3).*

# The summer sun: a landscape with intense light

**0**

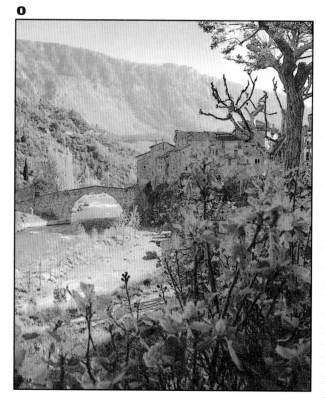

We now move on to the exercise section of this book, beginning with a brightly lit, summery landscape, illuminated by direct sunlight that provokes exceptional chromatic vivacity and greater contrast between the areas of shadow and light. To do this exercise, which will be painted with acrylics, we have the help of Josep Antoni Domingo, a renowned professional in the world of painting and illustration. The subject is this mountainous landscape in Catalonia, Spain with a dominant foreground with a village and a bridge and high mountains in the distance (fig. 0). Acrylics are highly appropriate for painting landscapes, you will find that both the material and the work method are easily adapted to each different need. Some landscapists always work from nature while others base their paintings around a combination of paintings and photographs. The latter possibility, although less immediate

**1**

and spontaneous, is more suited to the exploration of the variety of techniques that acrylics are used for.

Fig. 1. The artist starts off by drawing the forms of the flowers with light strokes of a number 2 pencil. Then, with a medium, round brush he paints the sky with cobalt blue and a touch of white. After that, he uses a little Garanza red, cobalt blue, white and a tiny amount of ochre to form the gray that he uses to start work on the mountains. In most mountainous landscapes, hills and mountains always dominate the composition and the sky plays a minor role. The forms that they create are an artist's delight, from the soft curves of the foothills to the jagged forms of the cliffs and peaks.

Fig. 2. Alternating the proportions of

## MODELS

2-. *The Retiro* by Manuel García y Rodríguez (private collection). The contrasted effects of light and shadow are not only effective, but also highly attractive to the spectator. These patterns of light are an excuse for playing freely with chromatic contrasts and opaque pastes of color.

**1**

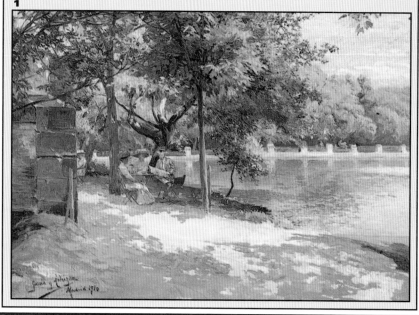

**2**

each of the different colors that are mixed to make the grays of the background, the artist paints the different shades that color the background. Adding red and green to the original mixture he gets the different gradations that are used to paint the buildings in the middle ground. Then he colors the foreground with an ultramarine blue and Garanza carmine wash. The artist prefers to apply a basic wash to each area and then construct the textures and forms with denser and more opaque strokes. Look at how the paint is distributed softly onto the surface to achieve the gentle effects of the patterns of light on the mountainsides.

Fig. 3. He has painted the roofs of the houses with a pale red, the color of the river bed with cadmium green, the trunk of the tree in the foreground with burnt umber and a touch of cobalt blue, and finally he uses a touch of permanent green to paint the mass of leaves that covers part of the branches in the bottom right hand section of the painting. Even at this stage the trees and the mountains, the houses and the bridge have been covered with wide areas of color. The structure of the painting is almost abstract, but there is still enough detail to identify the different elements of the composition.

Fig. 4. The main aim of these first steps is to get a first general intonation that can be worked on later as the individual forms and details are added. The colors that we apply to the support take on meanings according to their contexts; in other words, a green will be more or less light depending on the colors that surround it. That is why it is so important to cover the white of the paper as quickly as possible, because it

**3**

**4**

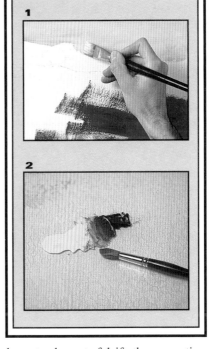
has a tendency to falsify the perception that we have of colors due to the effects of simultaneous contrast. At this stage, the construction of the colors has considerable depth that has been created by using transparent veils of paint diluted in water. The trees in the distance appear to be simplified, based on careful observation of their principal characteristics. The same could be said of the houses in the middle ground. Although the aim was not to represent the trees in too much detail,

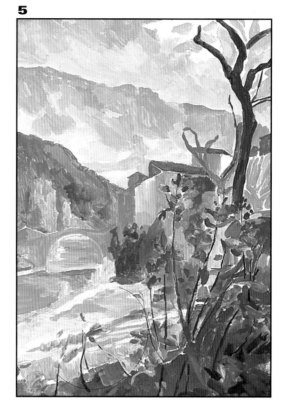

## TIPS

3-. Brushstrokes keep their form better when they are applied with a medium and water rather than just water, and that way they are easier to control too. Just like with watercolors, fluid washes should be applied quickly and knowingly before they dry.

4-. Unsatisfactory areas can be corrected with veils. For example, if the background of a landscape seems to stand out too much on the surface, it can be made to seem more distant with a cool blue or gray-blue wash on top.

3

4

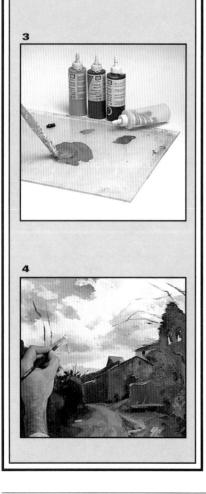

they still look completely convincing Fig. 5. The artist has now painted the river with an emerald green and a touch of violet, the bank with touches of orange, and the vegetation that appears beyond the bridge with colors that contrast vividly against each other. Having painted a few more details in the middle ground, he returns to the foreground to work on the effect that the vegetation nearest to the spectator needs to produce. He moves on to complete the leaves on the branches with new green tones that are somewhat lighter than the earlier ones. This can be done by simply adding a touch of yellow to the permanent green that was used before. With a touch of Mars red he draws new branches in the upper right hand section.

Fig. 6. The artist has finished covering the white of the paper with different washes.

Having got this far, the artist puts his medium brush to one side and takes a lower caliber one. It is time to think less about the whole and concentrate more on textures, contrasts of light, the forms of each element and, definitively speaking, paying slow and careful attention to every detail. But, remember one thing, you cannot add new colors to the piece without considering those that act as base colors, the new layers of color that the artist superimposes need to relate to those that already exist and should serve only to darken or lighten the color in any given area, or to add new details and accentuate forms that already exist, such as the branches in the foreground, which need to look more detailed because of their proximity to the spectator.

Fig. 7. The dark trees in the foreground

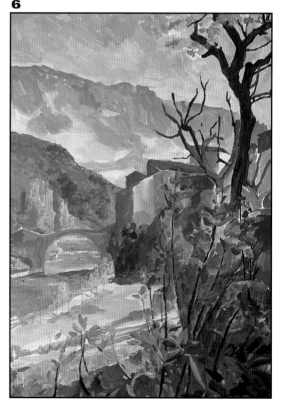

form a frame within the frame of the actual picture. This increases the sense of space, because the foliage at the foot of the composition draws attention to the foreground of the picture and distances the image of the village and the mountains. Compare the vegetation in the foreground with that in the distance and you will see how much richer those colors appear as a result of the direct sunlight that falls upon that area, while the closer vegetation, because it is in the shade, seems bluer, duller and somewhat colder. However, the foliage in the foreground has been carefully studied and beautifully described. Look at

## MODELS

**2**

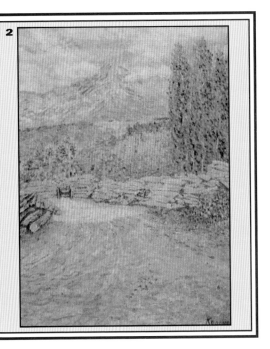

1-. *Aralar peak* by Darío de Regoyos (private collection). Here is a fairly similar composition to that painted by Josep Antoni Domingo in the exercise. Notice how the sunlight puts extraordinary life into the colors of the landscape. The atmosphere colors the mountain in the distance while a shadow tinted with violet is thrown across the path in the foreground. Compare the color of the soil on the path when it is under the sun to the part that is in the shade

**7**

the variety of tones in this area, and the thin brushstrokes that have been used to define the texture.

Fig. 8. In this painting there is a marvelous array of warm colors, saturated with a clean brightness that comes as a result of direct sunlight, contrasting with the blues, violets and grays of the areas of shadow. The spectator's eyes are always drawn in by the strong tonal contrasts and by the long, angular

**8**

forms, so that the bridge, with such a dark color, stands out naturally as a focal point of the painting. That is why, for this final step, you should spend some time accentuating the contrasts between light and shadow, trying to darken the foreground, the bridge and the facades of the houses on the left even more. This way, as a result of contrast, the rest of the painting seems lighter. Leave a few lighter areas on the right. Darkening these areas would be a mistake because the middle ground could get confused with the vegetation in the foreground and end up spoiling such a carefully constructed use of the *coulisse* effect.

# The winter sun: a landscape with diffused light

**0**

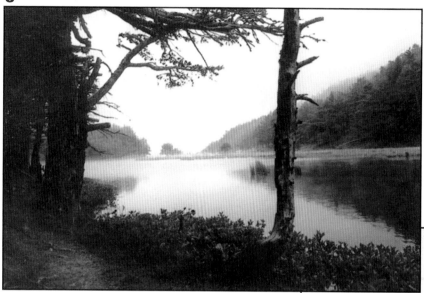

In this exercise you will learn how to create a sensation of depth through interposed atmosphere. To do this we have chosen a simple landscape that contains highly defined forms and colors in the foreground, while the distance is marked by low, misty contrasts. Winter light tends to be duller and more diffused than that of the summer and even more so in a landscape with a cloudy sky like this. For this exercise, we are going to be working with an expert watercolorist,

**2**

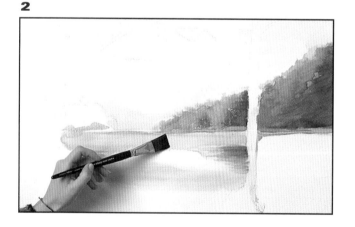

Ester Llaudet. The model is this view of a lake seen under a soft mist (fig. 0) and the medium we will be using will be watercolors.

Fig. 1. First of all, the image is outlined in pencil and lightly fixed. Before starting, the artist dampens the surface of the paper. The paper needs to be dampened as if a wash were being applied, using a large brush or a sponge. If the paper is properly stretched out and has been dampened homogeneously, the lines of a well-loaded brush should run smoothly along the surface. Start working on the more distant

planes. Your main objective is to define the vegetation along the bank of the lake. Fig. 2. With permanent green, ochre, cobalt blue and Payne's gray the artist constructs the distant planes and the first reflections on the lake. With a flat brush, the strokes can only be applied from left to right, that is to say, horizontally. The application of washes is one aspect of watercoloring that grows with experience. The background tones need to be soft and show little contrast. The effect of depth in

**1**

## MODELS

1-. *Windmill in the north of Wales* by David Cox (Victoria & Albert Museum, London). Winter days are characterized by gray skies, diffused light, leafless trees and the dull colors of the landscape. Notice how the color of this landscape is made up of greens, neutral browns and grays.

**1**

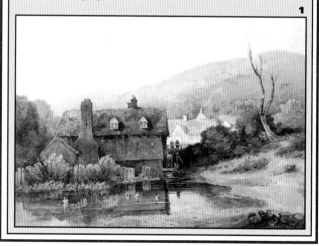

**3**

this cloudy scene is based on the tones and colors reducing the intensity as they increase the distance between the objects and the spectator.

Fig. 3. The upper outline of the vegetation is softened with a damp brush, so that its silhouette is less strong and does not contrast too much with the sky. The reflections on the water are now finished, and you should be able to see how flat and schematic they are. The blurred colors of the surface of the water are painted by applying the technique of wet on wet, mixing emerald green with Payne's gray in

the areas where the reflections are more intense, and Payne's gray with ochre where they are more sinuous, near to the far side of the lake.

Fig. 4. On the right of the picture, the artist has spread a thick Payne's gray wash to define the form of the tree trunks in the foreground. As you can see, the trees in the foreground are intensely and clearly painted, with strong contrasts of light and shadow, while the vegetation on the far bank has far less defined branches, textures and areas of light and shadow. This distinction is made to increase the ef-

**TIPS**

1-. If you spread a wash over damp paper, you will find that the paint tends to run and does not accumulate at the end of each stroke. The damp surface spreads the paint just like when you paint wet on wet.

2-. It is important to have a good idea of how to choose the right paper that you are going to use for wet on wet painting, because if it is very damp the paint will run more and faster.

**1**

**2**

**4**

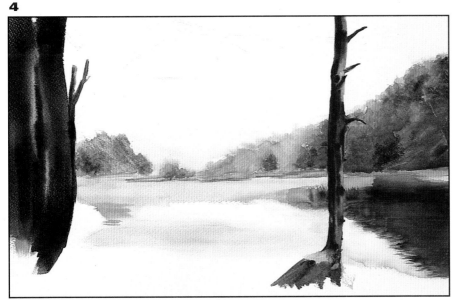

fect of distance in the image and therefore to make the effect of depth more apparent.

Fig. 5. The details in the foreground, such as the branches, should be painted with a small, round brush, with the paint being lighter and more saturat-

**5**

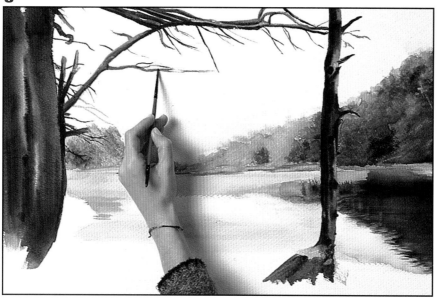

ed. Look how the upward push of the dark trunks center the intensity of the piece. The trunk on the right seems more defined than the section on the left. You can see the colors that the artist has used to recreate the texture of the bark: Payne's gray, violet, ochre and Venetian red.

Fig. 6. For the set of vegetation in the foreground, that is to say, in the lower section of the painting, lighter touches have been used than those that appear in the trunks and branches. She has painted the vegetation in the foreground with a brighter green than the one that appeared in the actual model, due to the need to provoke more contrast with the cold surface of the water. It is sometimes necessary to exaggerate or reduce the colors and forms of certain features so that they are more unified and to create the optimum chromatic interest. Remember that painting a cloudy landscape does not necessarily have to involve only using a limited range of just two or three grays and similarly dull colors.

## TIPS

3-. A brush with square bristles can be extremely useful for softening the hard borders of a watercolor.

4-. Blow liquid paint so that it spreads over the paper and forms the branches of the trees.

**3**

**4**

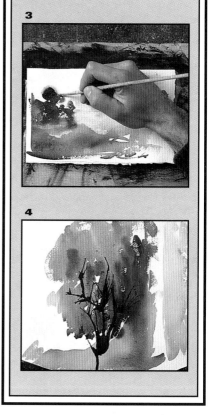

**6**

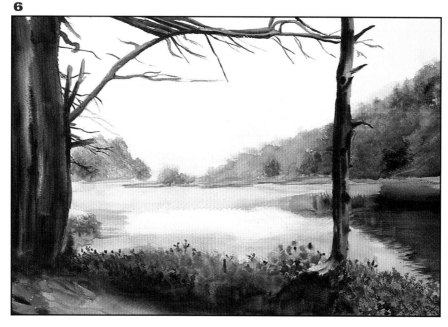

Fig. 7. There are just a few details left: more definition of the vegetation at the bottom of the picture, scraping the roots of the trees with the opposite end of the brush, and finishing off the painting of some of the leaves on the trees at the top. As you can see in this painting by Ester Llaudet, it is possible to achieve a great sense of depth and subtlety in an image by using different tones of the same color by incorporating techniques such as the softening of outlines, washes and

degradations. Notice how the distant vegetation is painted in a grayer shade as a result of the impact of light and the amount of humidity that there is in the atmosphere. When it is about to rain, vegetation tends to look a little bluer.

## MODELS

2-. *Venetian canal* by Manel Plana (artist's private collection). The absence of intense sunlight even pales the colors of such a colorful city as Venice. The artist, in trying to show this image of a cold Venice, has used an almost monochrome range of colors that are clearly derived from gray.

**2**

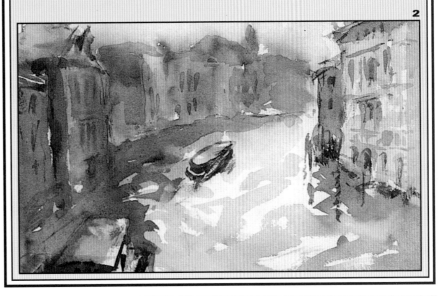

**7**

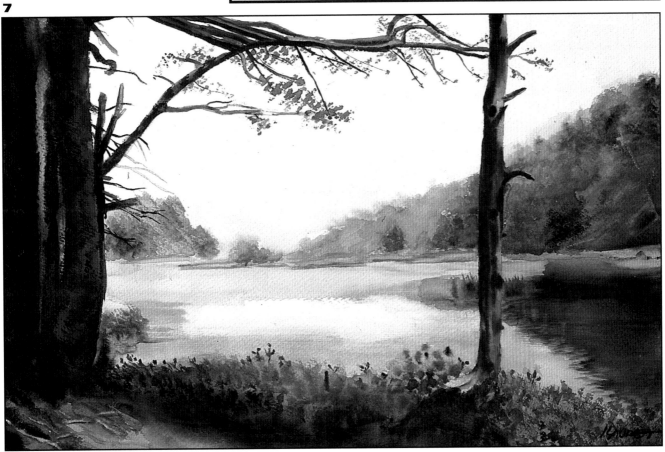

# A sunset

In this exercise we are going to paint a sunset, but we won't be looking directly at the sky or trying to paint the patterns of light that surround the sun at this time of day. The sun is going to be behind us, and we are going to be looking at how a sunset affects a landscape, in this case over a park in Greenwich, London (fig. 0). The chosen artist for this particular piece is Óscar

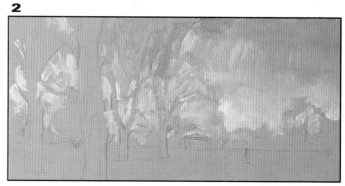

Sanchís, and he is going to be using oils to paint with the opaque color technique.

Fig. 1. The artist has made a preparatory sketch with a number 2 pencil on an ochre-yellow background. The color chosen for a tonal background always depends on the subject,

## MODELS

1-. *Lausanne: sunset* by William Turner (Tate Gallery, London). Turner painted sunsets like nobody else. In his watercolors, the vivacity of the sun is transferred to other elements of the landscape that also appear in burning colors that are surrounded by a thick fog.

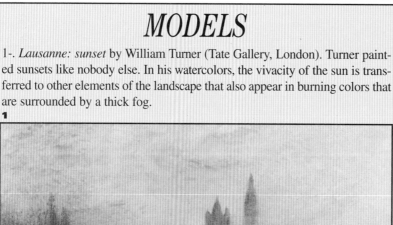

and in general it should be neutral, somewhere between the lightest and darkest colors of the painting. The background color should be subtle and discreet so that it does not excessively modify the colors that are painted over it. Fig. 2. As is becoming quite normal with professional painters, Óscar Sanchís paints the sky with more intense, blue colors at the top that get more yellow and violet as they approach the horizon. The artist should use his dexterity to create the illusion of a bright, shining light in the sky. One way of doing this involves mixing a few warm colors with the yellow and the ochre-yellow of the support itself, along with blues and violets. The warm colors will appear more intense due to contrast. As you can see, the artist starts clarifying the main branches of the trees on the right as he paints, which should be the same color as the support.

Fig. 3. Once the sky has been painted

**3**

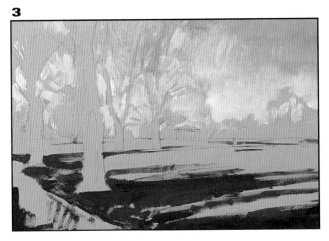

with permanent green and a little burnt umber, prepare a mixture that will cover the blanket of grass in the park. We will paint from the darkest colors to the lightest, so you need to start with the shadow that the trees cast. Remember that when the sun is low, the shadows that are cast across the ground are always long and pronounced. You do not need to paint the shadows too accurately, for the time being it is enough to color the paper and leave the lighter spaces unpainted.

Fig. 4. With the same burnt umber that we have just added to the mixture we

**4**

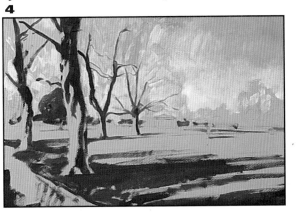

used for painting the shadows, paint the darker areas of the bark of the trees. Try to model the forms of the trunk so that there is a better sense of volume. Just as you did before, leave the areas that receive direct sunlight blank because they will later be covered with livelier, lighter colors.

Fig. 5. With a little Mars red, cadmium red and sienna, paint the area that is lit by the orange light of the sunset. Blend the reddish colors of the sunlit section with the dark brown of the shadowed

**5**

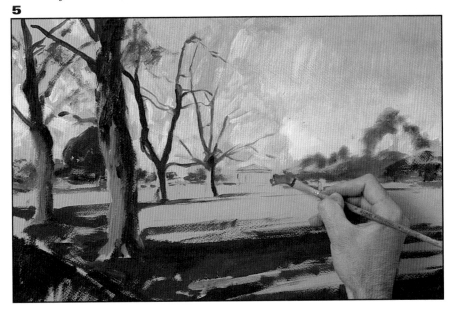

area by lightly passing your brush along the divide between the two colors, so that the transition between the two colors is softer, less evident and brusque, and more in accordance with the cylindrical form of the tree. Now take a little cobalt blue and use a medium brush to add a few touches of

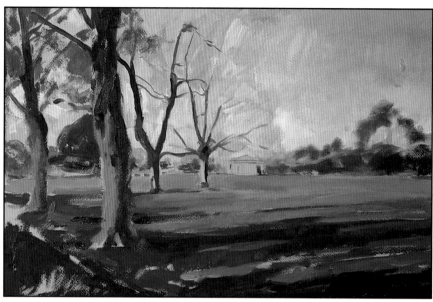

3-. The color and tone of a background have a lot of influence on the final appearance of a painting. Choosing to use a background of one color or another can put more warmth or coldness into the image.

4-. The technique of uniting two adjacent colors should involve the use of a clean, dry horsehair brush that should be brushed repeatedly over the border between the two colors so as to mix the colors on either side.

3

4

color to the shadowed part of the trunk in the foreground and the branches on the rest of the trees. Add a touch of carmine to that same cobalt blue and spread violet strokes over the background of the painting.

Fig. 6. To paint the blanket of grass the artist has used three colors, which are mixed in unequal proportions to modulate the light and prevent the surface of the ground being of too uniform a color. This way we can see the presence of ochre in the sections of grass that are nearer to the shadows of the trees and a cleaner, purer green in the more distant areas, nearer to the row of trees in the background.

Fig. 7. Now take a small brush and paint the network of branches in the trees using a mixture of burnt umber and a touch of violet. You don't need to add too much detail, the most important thing is to insinuate the organic growth of a tree rather than trying to make the kind of illustration that would be perfect for a textbook on botany, but unsuited to an oil painting.

Fig. 8. With the same small brush, continue painting each of the elements of the painting more precisely. Here, for example, the strong lateral impact of the sunlight at dusk should create very definite shadows and increase the

# MODELS

2-. *Partial view of Horta* by Pablo Ruiz Picasso (Picasso Museum, Barcelona). See how, in this small oil color sketch, the imminent sunset sends orange, dark gray and ochre colors over the foreground and more violet tones over the mountains in the background.

**2**

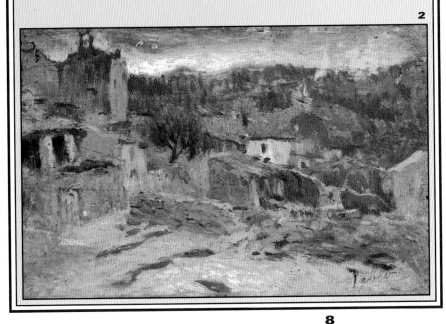

the panorama and point towards the horizon. Try to make this effect more powerful by outlining and contrasting the shadows on the ground.

Fig. 9. As you can see, the artist has touched up the background, defining it somewhat more freely, without making it too accurate. Also using the small brush he has painted the sky that can be seen through the branches of the tree and has added a few touches of texture to the grass in the foreground. In the finished painting, the light of the sunset gives the artist a rich range of colors, going from yellow-greens and oranges to deep blues and violets. Notice that in this finished picture, the color of the support is still visible through the paint in the lower section of the painting and in the sky. In doing this, it acts as a harmonizing element that unifies the colors of the image.

**8**

three-dimensional appearance of the tree. Both linear and atmospheric perspectives come into the equasion; the space that is so carefully constructed through the marvelous combination of warm and cool tones, and the long shadows that are cast across the grass, distance

**9**

# A sunrise

Many landscape painters find sunrises to be a highly attractive subject. Anyone who lives in a city loves having the opportunity to see how the sun comes up in a natural environment. The absence of buildings allows for a much wider field of vision, which is why most artists like to work in the countryside, where they can reflect the feeling of width and solitude that one feels as the first light of day appears in the sky. One of these is Antoni Messeguer, who, using watercolors, is going to show us how to paint a landscape under the dawn light (fig. 0). The subject is this plain seen from one of the towers of Salzburg castle in Austria.

In this scene there are two important features that Antoni Messeguer feels determine the nature of the piece he is about to paint. One of those is the light in the sky, which is what gives the scene such an emotive character and that will be obtained by contrasting it with the rest of the landscape that is under the shadow. The other important aspect to be kept in mind is depth, which shall be shown through the loss of detail as the scene

moves towards the horizon.

Fig.1. Now that a general idea of how the painting is going to be tackled has been established, start drawing with a thin horsehair brush. The artist has chosen a raw umber to mark the outline because it is the dominant tone in the scene that he is going to paint and will allow him to then merge the lines of the drawing with the areas of color. After careful observation and choosing the fit of the picture, start drawing the battlements in the foreground and the nearer of the trees. Carry on painting each element simply until you reach the horizon. Notice

## MODELS

1-. *Landscape* by Auguste Ravier (Drawing Cabinet at the Louvre Museum). Dawn is often accompanied by a tenuous morning mist that blurs the features of a landscape. Notice how cleverly this watercolor transmits the solitude, tranquility and slowness of life at this time of day. A good watercolor not only needs to represent, but also to transmit.

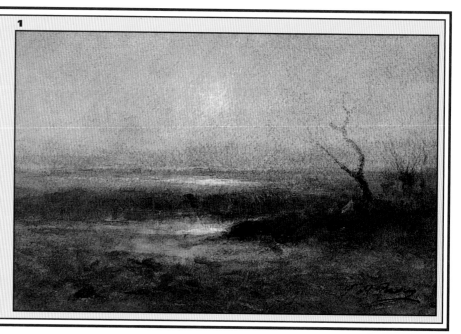

**3**

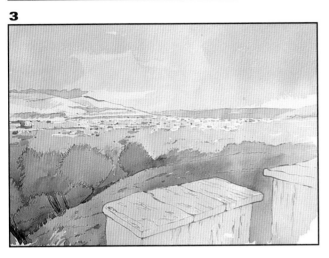

that you do not need to show every feature in any particular detail, but just to draw the most characteristic elements that make up the scene.

Fig.2. The artist moves on to the coloring of the painting, first applying the colors that dominate the image in the large, blank spaces. First tint the surface of the sky with a yellowish ochre in a very soft wash, with hardly any degradation, leaving a few spaces near to the line of the horizon that will be used later for putting in a few lights. Now mix the same ochre with a small quantity of raw umber and paint the tower battlements in the foreground. With medium intensity burnt umber, start suggesting the

most intense shadows in the landscape, such as those in the group of trees on the left. Fig. 3. Keep adding successive washes to the surfaces of the elements that make the watercolor look deeper. You now need to distribute the first general values that will serve as our guide for painting the colors of the piece. Use the same color as you did for the sky, but now more intense, to paint the sparkles of light that appear on the horizon as a result of the imminent appearance of the sun. With a burnt umber wash and a touch of violet, paint the field in the lower section. Do it carefully, silhouetting the battlements and trying not to invade the space in the foreground that you have already painted. Apply shades of dark cinnabar green and a violet wash to define the intermediate planes of the landscape.

Fig. 4. If you look closely at the model, you will notice that the landscape is almost hidden in the darkness. The

*TIPS*

1-. If you want the drying process to be quicker, you can use a hairdryer or blow. Never attempt to shake the painting dry.

2-. To get a more uniform wash when applying color to the sky, the artist has dampened the paper with a small piece of natural sponge.

**1**

**2**

artist can get over the problem of this excess darkness by lightening the foreground or even inventing whatever vegetation is not visible in the photograph. Remember that painting is interpreting, you do not have to stick to whatever the original model offers. Searching for greater contrast between the architectonic elements in

**4**

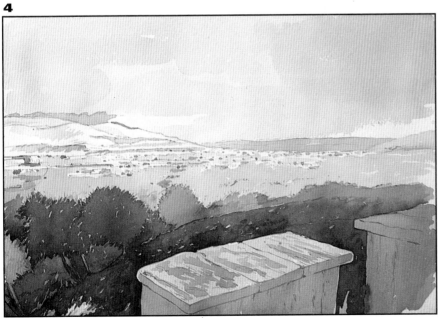

**5**

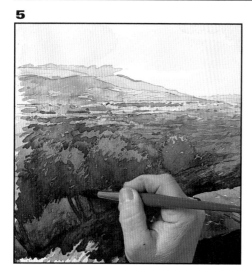

the foreground and the landscape, paint the vegetation at the bottom of the picture with a mixture of ultramarine blue, burnt umber and a little carmine. If we mix these three colors in unequal quantities we get the same chromatic subtleties that the artist has put into his work. With a tenuous cobalt blue, the artist paints the shadowed part of the battlements and then with burnt umber he tries to add a certain amount of volume to the surface by superimposing a few irregular layers.

Fig. 5. With a medium round brush, keep describing the vegetation and forms in the landscape. This means recreating the texture of the vegetation and its irregularities as you paint, making a few short strokes that are well saturated with color and carefully applied. You should work on the middle ground and the more distant planes in a similar way, using less detail as the landscape moves further away. These strokes must be applied on dry, when the previous washes have dried out completely, because if they are not, colored strokes tend to mix into the colors of the background and the details and textures will neither be clear nor defined, but imprecise and blurred.

Fig. 6. The artist has taken the small brush again and painted the effect of the battlements in the foreground. He has worked on the textures of the stone by adding irregularities and cracks in its surface. Look at the shadows of the outline, and notice how they have irregular edges that help to describe the characteristics of the material better. Notice how the different planes of the landscape present a different chromatic tendency. The foreground is dominated by the presence of browner and greener tones, the middle ground is far less clearly drawn and is a mixture of dif-

**6**

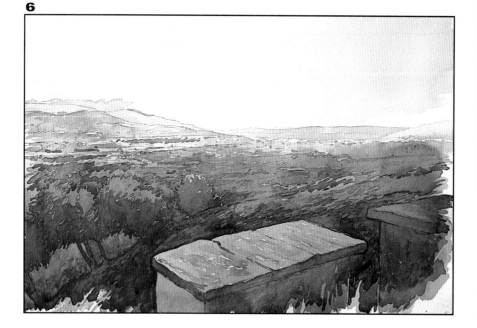

ferent violet washes and the tendency of the mountains in the distance is clearly bluer. The artist has managed to create atmospheric effects by defining the nearer forms and blurring the distant ones.

Fig. 7. The artist keeps on working,

# MODELS

2-. *Sunrise at Stonehenge* by William Trost Richards (Brooklyn Museum). Sunrises tend to throw cool shades over landscapes and make them seem colorless and monochrome. The patterns of light in the sky are not usually as bright and impressive as those of a sunset.

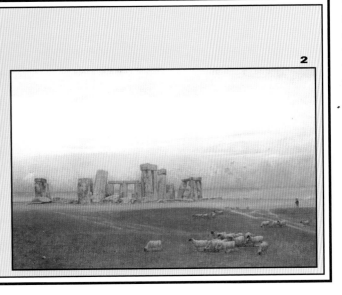

working until he reaches the stage illustrated here in which only the final touches are left to be done. Before he decides that the painting is finished, the artist intensifies the colors of the sky with softly applied violet-grays and oranges, forming a curious horizontal degradation effect. Redden the clouds on the horizon so that the white of the paper contrasts even more and therefore produces a stronger sensation of light and dark. The rest of the landscape also suffers modifications such as the darkening of the mountains in the distance and the middle ground, particularly on the left of the painting. The new violet washes let the form of the trees in the bottom left hand section of the picture stand out even more

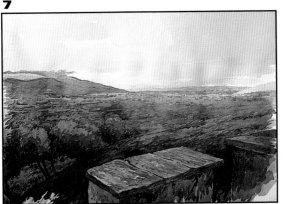

age as a whole and not build it up in sections. A modification to one part of the picture can alter our perception of other areas. Intensify shadows in the rest of the landscape, accentuating the volumes of the trees and the visual effects of the more distant vegetation.

Fig. 8. The artist keeps now trying to define the texture of the stones even more. He does this in surprising detail, trying to describe all of the irregularities of the texture of the material with painstaking care. If you compare the state of these stones in each illustration, you will see how they have gradually got darker along with the landscape so as to integrate the foreground into the overall harmony of the image. In the same way that he rectifies the foreground he also progressively darkens the general intensity of the landscape. If you look closely, you will notice how the shadows of the nearby vegetation appear darker and the orange colors of the sky are far more intense than they were in the previous illustration. This means that you should always paint the im-

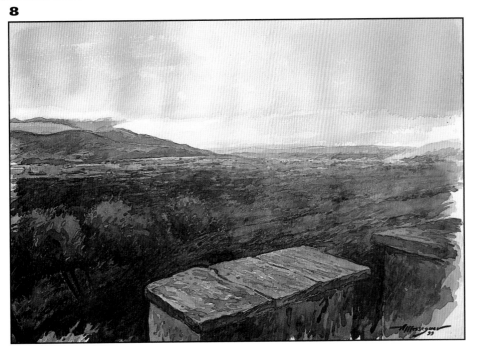

# Fog in a landscape

**0**

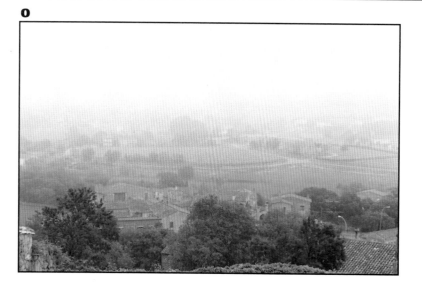

**1**

In the next exercise we are going to paint a rural view under thick fog. The subject is a small village called Pals in the province of Gerona in Spain (fig. 0). Painting foggy scenes with watercolors is a process that has to be done in a special way. The easiest and surest way of creating the tenuous degrada-tions and tones of a foggy landscape is to start with light colors and move on to darker ones. This completes the fusion of tones such that the tonal gradation appears more progressive. To learn how to do this we have the expert assistance of Josep

## MODELS

1-. *Sant Giorgio Magiore* by Manel Plana (artist's private collection). This painting has been produced using the monotype technique. Using this method, the artist can create interesting fog effects with expressive strokes. Fog softens the intensity of colors and blurs the profiles of buildings.

**1**

Antoni Domingo, famous for the subtlety of his veils. Let's see how he tackles the subject

Fig. 1. Josep Antoni Domingo is not an artist who likes drawing pencil outlines of his compositions. If he is painting a landscape, he takes a small sable brush and uses soft washes to draw the main outlines of the composition on the paper. As you can tell by comparing this illustration with the model, the artist has decided to modify the form of the image and make it a vertical one, which will help to strengthen the effect of depth produced by the fog. With a little Venice red he sketches the houses, and then with a few carefully applied emerald greens and permanent greens he starts suggesting the vegetation.

Fig. 2. With soft tones, he paints the first values for the group of houses situated in the center of the composition. This first involves applying a semi-transparent wash that covers the white of the paper. Spread a cadmium green

**2**

wash to the right hand sides of the roofs. This wash should be completely uniform. With cadmium green and emerald green paint the fields behind the houses so that they present a clear tonal degradation. When you do this, use a lighter green nearer the top and a more intense one further down. The mist and fog are described with delicate, almost invisible effects using pale colors and blurred forms that need to be applied sensitively. These extremely transparent washes blend their forms into each other and create subtle gradations of tone and hue that produce a soft, misty effect.

Fig. 4. Let the washes dry for a while and then get back to work. Spread a transparent, pink wash over the rather loud green one on the group of trees on the left.

wash across the bottom of the picture, though rather than monochrome but should look somewhat "eroded" (use small irregularities and occasional accumulations of pigment). You can create an excellent sense of depth and subtlety by painting an image with different tones of the same color.

Fig. 3. Now take a flat sable brush and start working on the effect of depth by painting the colors of the nearby vegetation with more intense greens: permanent green and emerald green for the trees and cadmium green for the bushes and grass at the bottom. Paint the first values of the roofs of the houses by applying a soft violet

**3**

You are doing this to harmonize the intense colors in the foreground with the rest of the composition. Intensify the colors and volume effects in the group of buildings with new, almost geometric, transparencies. The vegetation in

# MODELS

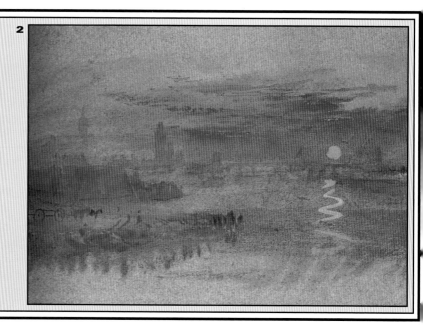

**2**

2-. *Waterloo Bridge in the fog* by Claude Monet (Hermitage Museum, Saint Petersburg). Monet tints the fog of this painting with an unusual warmth. The coming sunset generates an atmosphere filled with orange colors that contrast with the blurred, blue silhouette of the bridge. Fog is one of the climatic phenomena that most lets the artist work with most freedom, the vaporous effects of interposed atmosphere can be painted with a free hand.

**4**

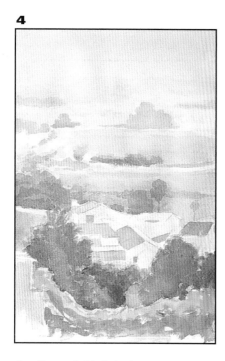

from more distant planes by applying colors more intensely and by defining the details better. This was never so true as it is in this example, where the landscape is submerged in a fog that quickly discolors anything that is seen from a certain distance. To create this effect of depth, take a small rounded brush and use a mixture of ivory black, ultramarine blue, permanent green and ochre to detail the foliage of the vegetation with short strokes that are superimposed over the previous washes. Concentrate the densest strokes and darkest colors in those areas that are more shadowed.

Fig. 6. Owing to an optical effect, the more contrasted foreground throws the rest of the landscape into the distance. With the same small brush that the artist used for the foreground, intensify the colors of the houses and add new values, spreading new bluish

washes over the facades in the shadow. You should also apply second values to the vegetation in the distance. Superimpose new violet washes over the ones that are already there, making sure that the vegetation does not look flat, but that it has a clearly voluminous appearance. The weak sun scarcely shows through the fog that smothers its shine. The delicate forms

**5**

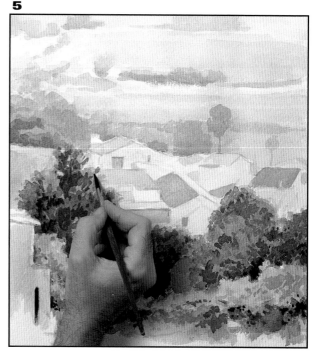

the distant fields is insinuated with soft violet washes. The subtlety of the colors is created by using optical mixtures made by superimposing transparencies. To make them, the artist let the paint dry completely before he added the next layer of color. Some highly subtle effects can be made out of colors when they are applied as thin, superimposed washes.

Fig. 5. A foreground is distinguished

**6**

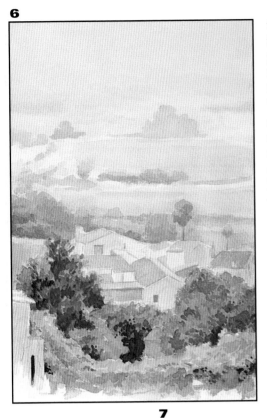

few architectonic details. The fragment of the house that appears on the right of the picture has been painted in more detail, but there is little more to do.

The subtle delicacy of the colors mixed using the transparency method is one of the most positive characteristics of this watercolor painted by Josep Antoni Domingo. The tonal depth that the fog provokes has not been achieved with the mixture of a deep tone for a wash, but by superimposing pale and thin washes. The effect, as you can see, is quite surprising. This is because of the interesting transitions of tones and the artist's ability to transmit the effect of depth so that the more intense colors at the bottom of the painting get discolored as the spectator's eye moves up the surface of the paper.

**7**

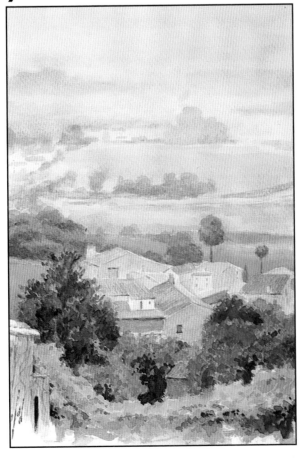

of the trees in the foreground are the only features that stand out in the foggy, diluted treatment of the composition as a whole. You should also notice how the artist has left the top section to the white of the paper. The general transition is from light to dark; in other words, there is a more intense foreground and a paler background, which has been created by superimposing washes of colors to the shadowed areas.

Fig. 7. Take a wide brush and paint with a very diluted blue over the upper section of the paper, for as you will see, you want to add just a minimal amount of color. The color of the houses has been intensified and a small brush has been used for a

## *TIPS*

3-. Smoothing tends to occur when a wash is applied to another that has dried. When a layer of paint gets dampened, the particles accumulate around the edge of the wash and form a darker or more wavy outline.

4-. When you paint with veils, the colors should be modified constantly in certain sections of the painting, so that they always maintain a fluid image that is globally configured.

**3**

**4**

# Desert climate

**0**

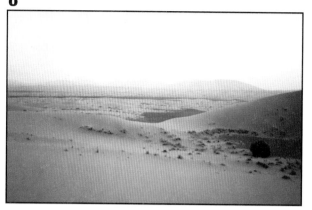

In the next exercise, we are going to use the wet on wet technique to paint a desert view in the Sahara, a sea of sand that extends right up to the horizon (fig. 0). The main problem here is going to be the representation of depth, because this desert landscape is ex-

**1**

tremely simple and neither includes many elements that distract our attention, nor many that require much attention to detail. For this exercise, we are going to working in collaboration with Óscar Sanchís, and the medium we will be using is watercolor.

Fig. 1. The artist starts the drawing with a B pencil that he uses to outline the fit, though he then erases it so that all that remains are light references. You should sharpen the point of your pencil so that your lines are clearer. First, dampen the sky with a little bit of water. Then, paint the sky immediately with a number 12 sable brush. Use ultramarine blue at the top, cadmium yellow in the central section and carmine near to the line of the horizon. After that, use water to make degradations and dilute and merge the colors. In order that the colors run properly, it would be helpful to have the board tilted at an angle. Fig. 2. Apply a medium

intensity violet color to the hills in the distance, using the same sable brush that you used for painting the sky. Prepare a more intense ochre and, still painting wet on wet, apply it to the central section of the painting. By working on a slanted support, you will find that that the colored washes are not uniform but that the colors run and make the ochre at the bottom of the wash seem a little more intense.

Fig. 3. The artist has continued painting the sand mountains with wide, ochre washes. To suggest the slopes of the dunes, he has touched up their outlines with burnt umber washes. While the paint is still wet, he has applied water with a sponge for the washes that make up the forms. Use the sponge along the top left section of one of the dunes to lighten its tone. You can let two areas of color merge by using the damp paper itself to create the mixture. In this particular case, burnt umber is

**2**

added at the bottom of the picture where, as you know, there was previously a wide ochre wash. After applying umber on wet, the artist tilts the support so that the colors merge nicely.

# MODELS

1-. *African beach* by Marià Fortuny (Museum of Modern Art, Barcelona). The main characteristic of the desert climate is the minimal presence of elements, not unlike the drawing of human figures with simple, scrawling lines. The desert climate is dominated by light. This light almost inundates the image as if it has exploded into thousands of pieces that are falling all over the scene.

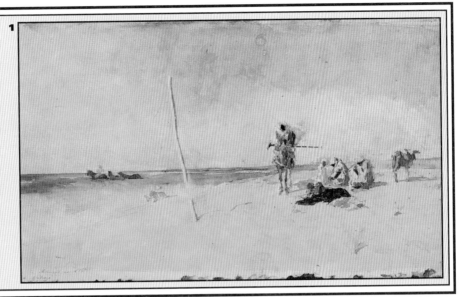

**3**

Fig. 4. When the previous washes have dried, the artist moves on to the details of the vegetation. He takes a somewhat smaller brush and with permanent green and burnt umber, he paints the irregularities of the terrain and the thicket on the right. With a medium gray, paint the area of shadow behind the dune, right in the middle of the composition.

Fig. 5. The stones on the ground are painted with tiny touches of color. In the foreground, these touches are applied when the washes underneath are completely dry. Paint the shadows in the more distant planes with the same color, but dilute it a little.

Fig. 6. A subject like this, with so few elements and details, needs to be painted quickly. And that is just what has happened, the artist only took about an hour to paint this watercolor. A landscape that includes such large spaces of uniform color is particularly

**4**

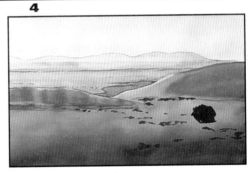

**5**

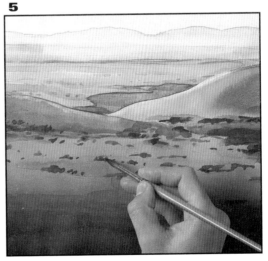

suited to wet on wet painting. It seems as if the colors are moving and merging on the surface of the paper with a life of their own. The high or low positioning of the horizon guides the spectator's eyes from the foreground to the background, creating a definite feeling of space. In this case, the horizon is somewhat elevated, and this helps to portray the immensity of the desert.

**6**

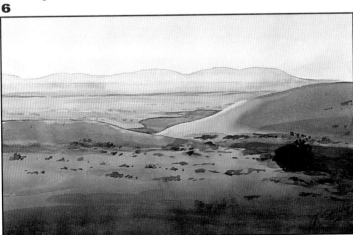

# Showers of rain

The next exercise we are going to show you involves using oils to paint a landscape on a rainy day. The main aim of the painting is to transmit the effects of rain across the landscape: how to alter colors, forms and, of course, atmosphere. To do this, the artist needs to decide which aspects of the landscape that he has before him need to be highlighted and which will not be useful in portraying the plastic concept that the landscape suggests. From the very start, the artist is going to search for unity in the way he deals with the color of the forms. For this exercise, we are once again

**O**

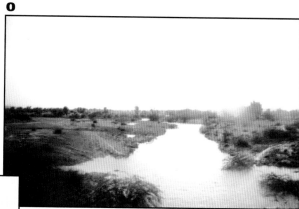

**1**

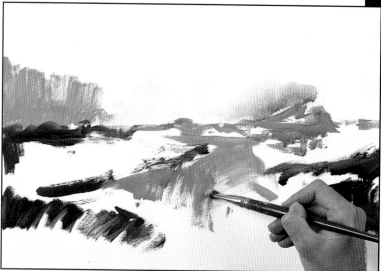

going to working alongside Oscar Sanchís. The model he is going to paint is a landscape in Rajastan, India, in the midst of a heavy monsoon downpour.

Fig. 1.This time the artist has opted for a rectangular frame in which the wide river becomes the main subject and the vertebral axis of the composition. As this is a study and due to the character that he wishes to put into the picture, the artist does not spend too much time on the outlining of his model, and with a few strokes defines the essential features of the landscape that he is about to paint. With a few dirtied ochre and burnt umber strokes applied with a flat brush, he represents the main irregularities in the ground and the darkest areas. This is done with a carefree expressionism, without trying to be too meticulous.

Fig. 2. The artist searches for the effect that the rain produces by sketching the sky with agitation. Óscar Sanchís interprets the powerful downpour of rain in an expressionist way, marking diagonal

lines onto a thick layer of oil paint with a horsehair brush.

He leaves a few spaces between the lines made with a flat brush. The strokes are parallel, overlapping and diagonal as he tries to define the effect of falling rain right from the outset. The sky seems gray in a clear tonal degradation. The upper part of the sky appears to be a darker gray than the areas nearer the horizon, which are dirtied with white and a mixture of white and ochre. Keep working on the water in the river with similar colors to those that you used for the sky, but making them thicker and using mainly ochre in the foreground.

Fig. 3. Now continue working on the surface of

## MODELS

1-. *Storm* by William Turner (Tate Gallery, London). The secret to transmitting the effect of a storm to the spectator depends on the artist's ability to dramatize the effects. This is complemented with a misty atmosphere and neutral, gray colors.

**1**

**3**

**TIPS**

1-. There are basically three types of brush used for oil painting: flat ones, conical ones and rounded ones. The first are used for painting large areas of paint, the second for thick strokes and the latter for applying specific details.

2-. The mixing instrument with fanned shaped sable bristles, occasionally known as a cleaner, is used to complete merging actions and for flattening the grooves caused by using teasel brushes.

the river with denser colors so that they are unified in one area of color. The gray of the water in the distance is united to that in the foreground by an ochre degradation. Describe the vegetation with a cinnabar green that is rich in hues made from mixtures of small amounts of dark brown and ochre. As you can see, the artist has managed to keep the original freshness in the picture.

Fig. 4. The artist keeps painting the sky with the same diagonal lines that he started with, but the continuous superimposition of layers creates a denser paint surface that gradually covers the

white of the paper. Paint the vegetation with permanent green mixed with a little emerald green and ochre. The dark gray tones at the edges of the river are painted by mixing alla prima, in other words, applying cadmium red, burnt umber, raw sienna and carmine directly onto the support. The vertical strokes on the surface of the water become horizontal, in clear contraposition to the direction of the strokes in the sky. The foreground appears slightly darker and is painted with ultramarine blue, burnt umber, ochre and permanent green, using nervous, disordered strokes with little apparent form.

**1**

**4**

Fig. 5 Now the artist strengthens contrasts, darkening certain areas, working the volumes with brushstrokes and looking for the details that will help describe the subject better. As he wanted to contrast the surface of the water with the sky and accentuate the sense

**4**

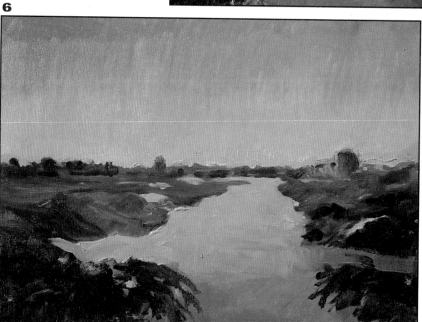

## TIPS

3-. Notice how freely the colors are mixed with the brush, the colors are together and then separated in just one stroke, creating an attractive, lively sensation. This way of painting causes the strokes to reproduce the lines of the bristles of the brush.

4-. The unequal, broken quality of a dry stroke can be extremely expressive, and the technique is particularly adequate for suggesting and describing natural textures and effects.

**3**

**4**

the right of the picture to open up a new flow of water.

Fig. 6. It is time to touch up the details in the landscape. First of all, with a soft, flat horsehair brush the artist has leveled out the effect of the degradation in the sky a little more. He has worked on the edges of the river, showing new shadows and branches with loosely mixed colors,

**5**

**6**

of depth, he has blended the colors of the water in the part of the river nearest to the horizon so that it now looks silvery. He leaves the colors of the water that flows into the foreground earthy and turbulent. His strokes near to the horizon are soft and blurred while those in the foreground are expressive and vigorous. You can see this in the daring strokes that the artist makes on

**7**

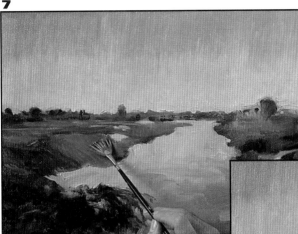

**8**

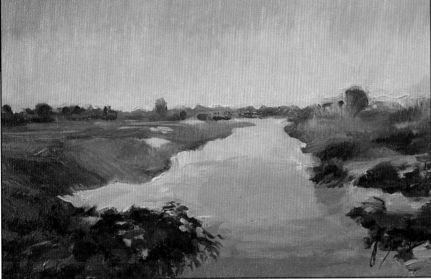

producing different grooves with each stroke. When applying thick oil paint over another layer of wet paint, the brush should be well loaded with paint so as to prevent the color of the branches in the foreground becoming muddy and not looking as intense as we would like. The color should be deposited in large quantities with the tip of the brush, and your strokes should be solid and held at right angles to the canvas.

Fig. 7. With a fanned brush, the artist works on the textures and forms of the ground by trying to blur the forms to show the effects of the rain. Remember rain creates a veil over a landscape that lightly clouds the edges of objects. So, a fanned brush merges the colors where they meet, but makes sure that they stay separate. It is important that this all happens in the same direction as the rainfall.

Fig. 8. And here is the finished painting. It is an excellent example of how an artist should interpret the model in real life by exaggerating certain effects to portray the right impression that rain produces as it falls. In this picture, the artist has used plenty of thick paint as is habitual in oil painting methods, capturing lighting effects with fast, sure strokes. The strokes that were used for painting the vegetation create small, broken pastes that suggest the rain that is falling over the ground.

## MODELS

2-. *Storm on the West Coast* by William Turner (Sheffield City Art Galleries). When rainy effects are painted with watercolors, the artist has different resources to think about. Rather than pasty colors, he needs to be much subtler. Atmosphere is more important than ever in these cases.

**2**

# Rain in the city

We have painted the effects of the rain in the countryside, now we are going to change the scene to see what effects rain produces in an urban setting. You will see that an urban landscape is tackled in a different way because here the rain converts it into a gray panorama, full of puddles and wet roofs that reflect the light of the sky. One of the

**0**

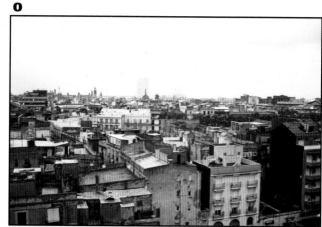

**1**

**2**

with a reliable representation of the architectural elements that characterize urban structures.

Fig. 2. You now have to add the first values. These should be quite watery and tenuous. If we start working with very light washes there is much less chance that

we will make any mistakes. In any case, if we do make an error, as the washes are barely perceptible, there will be plenty of time for correction as the painting progresses. As you can see, to color watercolors we use very grayish blues, violets, ochres and carmines.

Fig. 3. Use a wide brush to slightly darken the sky by spreading a new gray-blue wash when the previous one still has not dried. With a new wash, this time a medium tone of

most evident problems with these subjects is the plethora of planes and sight lines. A city can be a real headache as far as perspective is concerned. In this painting, the artist has chosen a view of Barcelona under a tenuous rain with an attractive combination of cold, dull colors (fig. 0). The neutral colors of the buildings relate to the overcast sky. For this exercise, we are going to be following the work of Antoni Messeguer as he paints using watercolors.

Fig. 1. A painting like this requires a highly elaborate preparatory sketch. So, you should start by drawing the simple outline of one of the buildings, without getting distracted by superfluous details. When you have managed to establish the basic structure of the buildings, start elaborating the drawing, showing each of the architectural features and any other significant details. The finished drawing should combine an exact linear perspective

## MODELS

1-. *The Prado salon* by Pablo Ruiz Picasso (Picasso Museum, Barcelona). As you can see from this oil painting by Picasso, you do not have to paint raindrops, it can be enough to just suggest it them using sad, dull and neutral colors, a sky covered by heavy clouds and puddles and reflections on the ground.

**1**

**3**

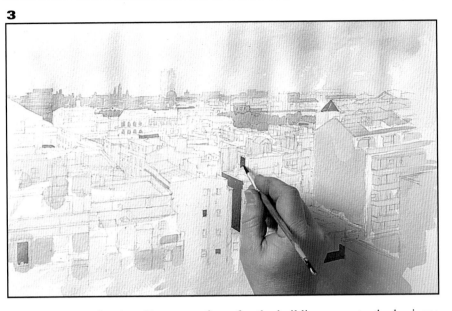

Payne's gray, paint the silhouettes of the buildings in the background, those ones just above the horizon. You do not have to be too accurate, just a rough outline will do. Take a small, round brush and start positioning the most outstanding shadows, in other words, the most evident tonal contrasts

Fig. 4. At this stage, you can already make out the main areas of shadow in the composition with violet washes in the foreground and a bluer tendency as the buildings get further away. The artist has used just two or three values

for the buildings near to the horizon; the skyscrapers are clearly identifiable, as are the domes and church towers. As you can see, with a few well-defined outlines and neutral colors the main horizontal and vertical lines have been added.

Fig. 5. Keep working on the volume of the buildings. Do this by adding new values that make patterns with those of before. The contrast or gradations of different tones gives the image as a whole more volume. For the time being, the artist has decided to leave the paper white for the wet

### TIPS

1-. I suggest that you sketch the subject a few times beforehand, separating the perspective into sections and thinking about the fit that you will eventually settle for. Such preparatory exercises are extremely useful for deciding on the definitive layout of your painting.

2-. The foreground is always important in an urban landscape because it needs to direct the spectator's eyes into the center of the image and inspire interest in the colors, forms and textures.

**1**

**2**

parts of the roofs. Look how, as Antoni Messeguer adds new details, he gradually darkens the general values of the painting at the same time.

Fig. 6. Now is the time to determine the position and form of the windows and balconies in the facades in the foreground. With a slightly blackened violet, start identifying the contrasts

**4**

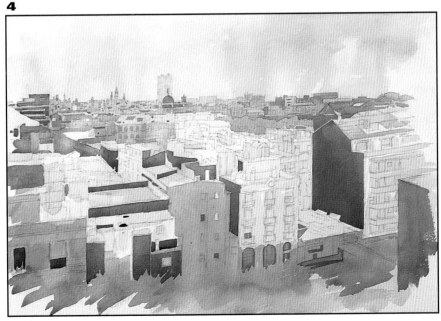

**5**

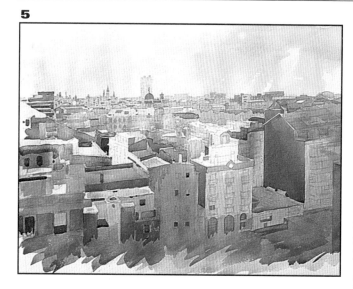

so that the more illuminated main facades of the buildings can be seen more clearly and their sides appear more shadowy. Always be selective as you paint, you sometimes need to exaggerate or reduce colors and forms so that the painting is more unified. Nevertheless, you should respect the harmonious range of gray colors. The tones and colors of a

**6**

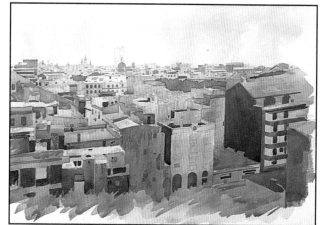

**7**

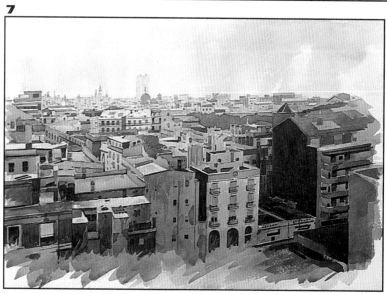

painting can be compared to musical notes. Too many tones would produce visual dissonance, whilst if they are controlled they produce the harmony that underlines the unifying effect of rain.

Fig. 7. With green, blue and gray washes, detail the windows, doors and Persian blinds on the nearer facades. The white of the roofs has been covered

with gray and very transparent washes that harmonize better with the image as a whole. Make sure that the tops of these coincide with the perspective lines of the buildings. By making the nearest houses darker and more defined than those in the distance, you will create a better sense of space in the painting.

Fig. 8. The last step is also the trickiest and most laborious of all and will depend on how complete you want the finished piece to look. You need

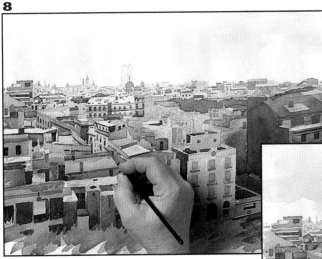

**8**

to paint the textures, working on the roofs of the houses by adding new details with a small, sable brush. Try to apply the paint in small strokes, modifying the colors and tones through careful control and modification of the mixtures and densities of the paint you use.

Fig. 9. The end result is an excellent composition in which ambience plays an important role. It would be wrong to try to paint the raindrops that fall on the buildings, the atmosphere, discolored buildings in the distance, overcast sky and wet roofs do enough to suggest its presence. You do not need to worry too much about perspective, but on the other hand, it is important because it gives watercolors like this the sensation of distance and helps suggest volume.

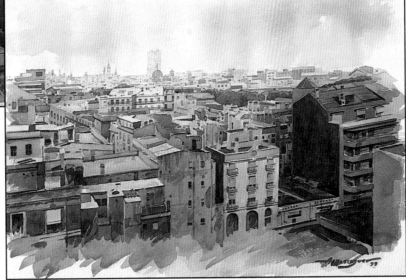

**9**

# MODELS

2-. *Stamford* by William Turner (Usher Art Gallery, Lincoln). Rain in a city is almost inevitably accompanied by human figures. The magnificent buildings lose detail so as to make the atmosphere the central feature. Notice how we can make out the silhouettes but it is less easy to make out the ornamental stonework.

**2**

# Lightning

**0**

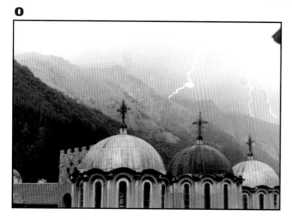

We are going to paint an atmospheric phenomenon that can only painted with the help of a photograph because it happens so quickly. We are talking about a flash of lightning. This electrical phenomenon might help you to add more vivacity and drama into your paintings of storms. The artist who is going to show you how to do it is Ester Llaudet, who has decided to use this photograph of storm-clouds over some nearby mountains as her subject. This photo was taken from a monastery called Rila, in Bulgaria (fig. 0). So that the composition does not look too plain, we have decided that some of the domes of the monastery church should be clearly visible at the foot of the picture.

Fig. 1. As always, start by modeling an outline sketch with a lead pencil. Notice how the artist does it, using lines to make a graphic representation, without any tonal values because if she were to draw the shadows they could mix with the grays of the pencil marks and spoil the picture

Fig. 2. With a medium brush, start painting the domes of the church. First,

**1**

**2**

**3**

## TIPS

1-. To stop liquid gum solidifying on your brush, you should first soak the bristles in soap and water, either by rubbing them against a bar of soap or by smothering them in soapsuds.

2-. In those places where you want a fluid or blurred outline, use your fingers to merge your washes.

apply a copper colored wash to part of the base that covers the windows and moldings. Paint the central dome with an intense burnt umber wash. The other domes should be painted with a mixture of gray, burnt sienna and small amounts of ultramarine blue. The lines should be applied on wet and downwards, going from the top of the dome down to the tops of the windows to help suggest the curved form of the surface of the structure.

Fig. 3. Let the first washes dry. Take a small, round brush and start painting the architectural elements in the foreground. With ivory black, paint the wavy ribs at the top of the windows.

**4**

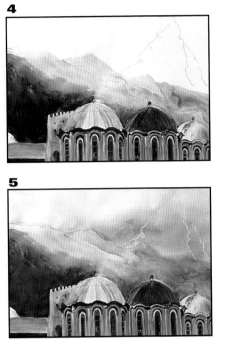

**5**

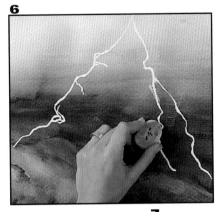

Also on dry and with a little diluted gouache white, paint the upper window frames, letting the wet color mix with the copper colored wash beneath it. Then touch up and outline the silhouette of the whole structure.

Fig. 4. Now start on the background. Paint the mountains. Use emerald green and a little burnt umber for the near side, followed by an ochre that has been dirtied with yellow, and then use an intermediate gray and more violet tones as the planes move further into the distance. Before starting work on the sky, cover the whole area that the lightning covers with liquid gum

**6**

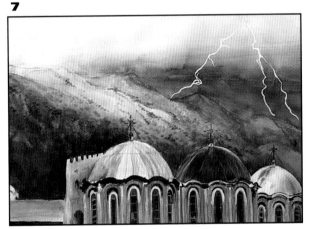

**7**

and let it dry for a while. When you have finished using liquid gum, you should always make sure that you clean your brush with plenty of water.

Fig. 5. Now you need to darken the right hand section of the sky with different gray and violet degradations, making them a little lighter near the top of the paper and more intense nearer to the mountains. You will see that the border between the mountains and the sky sometimes gets a little confused. The method of painting more defined shadows and contrasts than those that are seen in real life is a particularly popular one amongst watercolorists for highlighting the forms of the model, in this case to give more importance to the ray of lightning that, for the moment, is still under the layer of liquid gum.

Fig. 6. It is time to remove the liquid gum. When the watercolor is dry, rub it with an eraser to reveal the white of the paper again.

Fig. 7. Before finishing, detail the

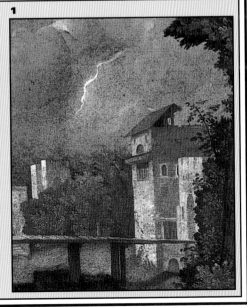

vegetation on the sides of the mountains and touch up the lightning with the same color you used for the sky, but much lighter this time, to avoid there being too much contrast and to harmonize the colors of the image. As you can see from the finished painting, reserving spaces with liquid gum is a useful method as long as it is used when it is really necessary and not purely for the sake of doing something different.

# MODELS

**1**

1-. This is a small section of an Italian Renaissance painting, perhaps one of the earliest examples of a flash of lightning appearing as part of a storm. Landscapes played only a small part in the Renaissance movement, usually as part of mythological scenes or as backgrounds to portraits, hence the importance of this painting which not only puts importance into the landscape itself, but also climatic factors.

# After a storm

Unexpected heavy rains often leave a drenched landscape behind them, with bright colors and reflections on the leaves that are still wet. Look how we paint this landscape after a heavy monsoon storm. For this exercise, using just two or three brushes and a very limited number of colors, Óscar Sanchís has managed to represent and also differenti-

the sky after leaving a heavy downpour behind them (fig. 0). The artist is

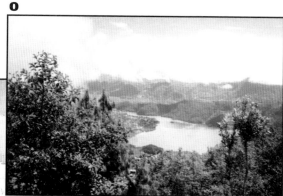

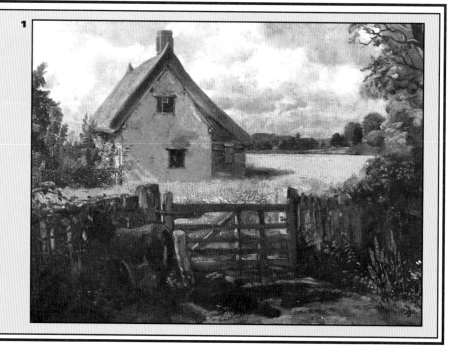

ate the solidity of the vegetation, the depth and brilliance of the water and the misty background of storm clouds that are moving farther away across

going to use watercolors for the exercise.

Fig. 1. The sky is painted quickly and loosely using the wet on wet technique, letting the colors of the storm clouds blend into the areas of clear sky, suggesting that the clouds are moving away at quite a speed. The lower parts of the clouds, where they are nearest to the horizon, have been painted with a violet wash. In the middle, the white of the support can be seen through blank

spaces. The top of the sky has been completed with a somewhat degraded cobalt blue wash.

Fig. 2. The artist continues working with the wet on wet technique. However, he is going to use the method in a different way to that which he used on the clouds to paint the distant hills. He first dampens the surface of the paper. Then he applies a first wash of permanent green and lets the tops of the mountains blend into the violet of the clouds. The borders between the land and the sky should be rather blurred and confused.

Fig. 3. Use a large, round brush to apply large areas of permanent green and cadmium green mixed with burnt

## MODELS

1-. *The house in the wheat field* by John Constable (Victoria & Albert Museum). In this painting we can see how the English painter deals so masterfully with the stormy clouds as they move on to shed raindrops over pastures new. In the foreground, the first rays of light are already visible as the sun starts appearing through the gaps in the sky.

**3**

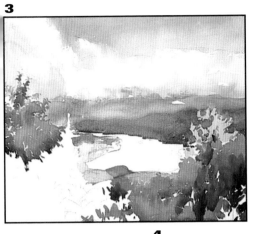

in the background. This implies that before we can paint the vegetation in the foreground we need to wait for the colors in the background to dry. If we do not, the colors could merge together and the foreground and background would not be so clearly distinguishable from each other. Fig. 4. Use ochre yellow and permanent green to finish off the mass of vegetation on the left. Now add burnt umber to the

**4**

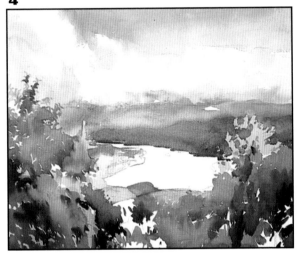

umber, ochre and violet, corresponding to the different forms and chromatic tones that are found in the vegetation in the foreground. As you can see, the picture is built up by moving in from the distance towards our viewpoint. Take care when you paint the leaves, they need to look more contrasted and silhouetted in relation to the colors

**5**

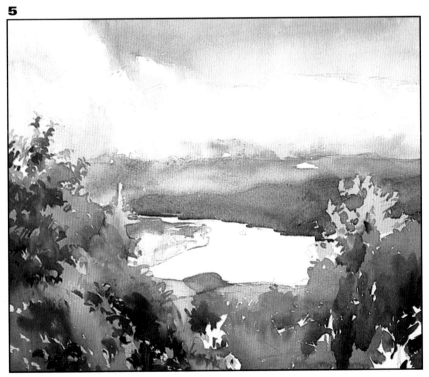

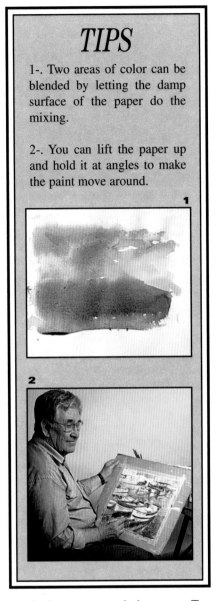

original green to get darker tones. Try to paint the basic forms of the vegetation and the changes of density in the foliage. Avoid covering the white of the paper too much; let the support breathe through at certain points. Leaving little gaps where the paper shows through adds a touch of variety to the image and breaks the monotony of so many uniform washes. Think of them as little sparkles of light that help make your painting look just that little bit more interesting.

Fig. 5. Keep working on the vegetation, but this time apply your washes on dry. This means you will have to

**6**

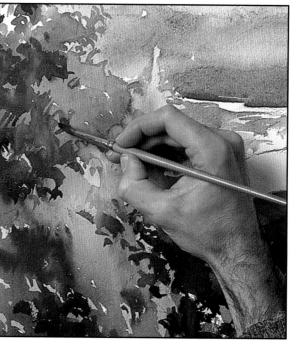



# TIPS

3-. You need to mix paint until you have found the right consistency. Diluted paint runs more easily than thick paint.

4-. White watercolor paint is rarely used and only to soften the freshness of a color. Wherever there are white areas, such as lights, you should let the white of the paper show through.

**3**

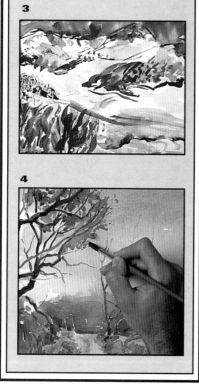

**4**

artist works. New washes are superimposed over the earlier ones. Look at the new green washes that Oscar Sanchís puts into his work, in the form of broken outlines that indicate where the areas of light and shadow

**7**

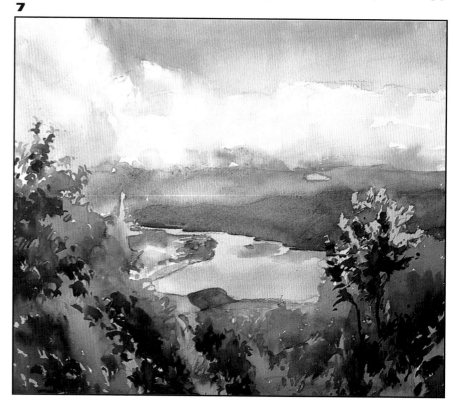

begin and end. You need to paint in single lines, taking care not to repeat any strokes. Remember that if you pass your brush over the same spot too many times, there is a good chance that you could spoil the surface of the paper.

Fig. 7. Paint the surface of the water with a highly transparent gray-violet wash. Take a short break and step back to have a good look at your work. After reflecting for a while, something that is always important, take a very small round sable brush and add new details and contrasts to the foreground. If you compare this illustration with figure 5, you will see how the artist has intensified the shadowed sections of the foliage in the vegetation. His strokes are quite varied, but they are strongly

wait until the lower layers of color are completely dry before you can add any new values to the vegetation. You should now be using a medium round brush that will be able to define the branches and leaves better, and use slightly more intense colors than you used before. The reason you are doing this is to put more volume into the foreground, which, because of contraposition should look more detailed than any of the more distant planes Fig. 6. This illustration shows how the

**9**

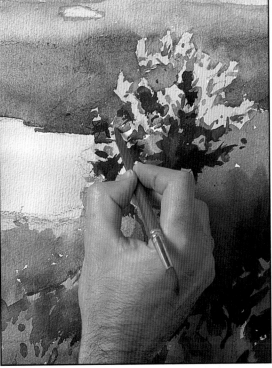
**8**

formed and create excellent results.

Fig. 8. Now you only need to resolve a few details. Spread a thick layer of wet paint over the tree on the right and scrape the surface with the opposite end of your brush. This can be an excellent technique for creating interesting textures when painting the green areas of trees and plants. Look carefully at the way in which the artist does this.

Fig. 9. As you can see from this illustration of the finished painting, the patterns of light in a landscape after a storm change the appearance of vegetation quite considerably. Because it is still wet, the contrasts and colors are much brighter than they would be normally. You can show this by using clean colors. So, as you work, you need to clean your brushes as often as possible to stop your colors dirtying on youir palette.

# *MODELS*

2-. *Greek Theater at Syracuse* by Jean Houel (Drawing Cabinet at the Louvre Museum, Paris). In this watercolor, the departure of the clouds, which the artist has situated to the left of the picture, is even more evident than in the previous model. As the sky clears, light emerges from the right.

**2**

# How to represent the wind

Some pages back I explained how it is not necessary to paint the actual rain to show a rainy landscape, and the same is even truer for wind, which as it is an invisible element, does not have a body at all. So, how do we go about painting the wind? We need to do it according to its consequences, in other words, how it affects its surroundings. This includes leaves flying in the air, bending

**1**

trees and branches, waving flags and so on. Óscar Sanchís is going to show us how to do this as he paints a charming rural view of a village in the Catalan Pyrenees (fig. 0). The landscape is suffering the effects of a strong wind. He is going to use oil paints for the task.

Figs. 1 and 2. These two illustrations show what the painting looked liked before and after a short period of a few minutes. Oscar throws himself straight into the task at hand, without making any pencil outlines. He knows exactly what kind of effects he wants to create and makes a surprisingly quick, unfocussed sketch that reflects the effects of the wind. It is not easy

**0**

**2**

to capture the fast moving effects of leaves and branches being blown by the wind, but it is important not to lose that feeling of movement. Do not try to freeze the moment, make a few measured lines and brushstrokes that reproduce that sense of movement and fluidity

Fig. 3. Paint the branches of the tree with curved, free and shaky strokes. See how well he has captured the basic gesture of this tree under the effects of the wind. At the same time, keep adding values to the rest of the composition with flat, teasel brushes. Use opaque paint for the foreground and middle ground, letting the tones merge together slightly to get across that feeling of a misty, unfocussed image that is so typical of windswept scenes.

Fig. 4. With a medium round brush the artist has outlined the forms of the bell tower and the roofs and windows of the houses. The trees and shrubs stand out for the variety of textures in them. Also, when painting from such a close point of view as the one we have here,

## MODELS

1-. *Palm trees in Nassau* by Winslow Homer (Metropolitan Museum, New York). Wind, as we have said, cannot be painted because it is invisible, but we can paint its consequences. In this painting, we can tell that there is a strong wind by the way that the palm trees are bending over. Try imagining this scene without the palm trees and you will see how the effect of the wind would be lost. It would just look like an overcast landscape.

**1**

2-. *Woman with a sunshade turned to the left* by Claude Monet (Louvre Museum, Paris). See how this artist has suggested wind through directional strokes in the movement of the woman's headscarf and skirt. If you look carefully, you should see how the strokes in the sky and the vegetation head in the same direction –to the top left.

**2**

**3**

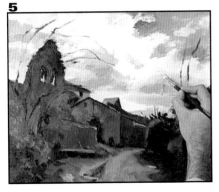

**4**

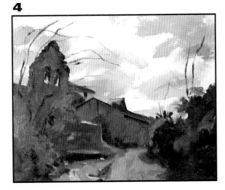

**5**

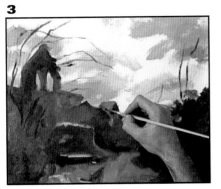

ture, to help accentuate the effect of the wind.

Fig. 6. Add new branches to the trees and use pastily colored lines to show the quality of the leaves blowing in the wind. As we said before, wind produces blurry, unfocussed forms in a landscape –not unlike a photograph

**6**

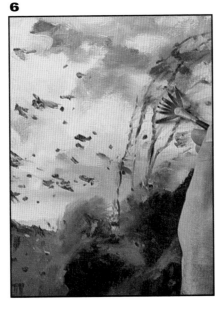

they present us with a delightful richness of details and varied colors. Whatever way the artist wants to integrate the trees into the overall image, their forms need to be studied carefully or they will not look very convincing.

Fig. 5. Now decide upon the form of the clouds by applying small variations of ultramarine blue, cobalt blue, violet and titanium white. As you can see, the clouds have well defined forms, have clear volume and owe much of their majesty to the sun. Clouds should always head in a general direction, in this case towards the right of the pic-

**7**

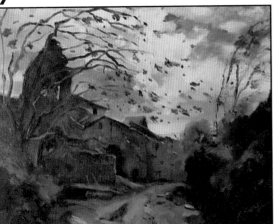

that is taken without holding the camera still enough. Make this effect more evident by using the soft bristles of a fanned brush to gently rub the paint when it is still wet.

Fig. 7. Finish the piece by painting the earth on the path with ochre, gray and sienna strokes. These should be wide and generous. As you can see, the artist has applied a few dark

touches to the vegetation to reinforce the foreground. Avoid putting too much detail into the fronts of the houses or they could lose their fresh spontaneity. To finish off his work, the artist has tried to increase the suggestion of wind with new raw umber strokes that suggest leaves being thrown up into the air.

# Ice: a frosty landscape

The artist Antoni Messeguer has chosen this winter scene as the subject for the next watercolor. The model, as you can see, is a view of some frost covered fields, somewhat diffused by a morning mist, in the French region of Camargue. This is an excellent opportunity for practicing ways of reserving areas in which the white of the paper is used to show the brightest areas of the picture. Notice that the main features of the selected model, the lines of frost, are practically in the center of the frame. This creates a better sense of balance and static that accentuates the feeling of solitude and the austerity of the

**1**

landscape. So, it is in the center that the artist accentuates the contrasts between the white areas of frost and the dark areas where the land is furrowed.

He will represent the foreground with less diluted colors and will blur and wash the colors in the distance to accentuate the sense of depth in the landscape.

Fig. 1. Start drawing the elements that define the landscape with a thin brush and umber paint. Use lines and touches with the tip of your brush to show the first, monochrome forms of the fields and think about the patterns of lights and shadows that are deter-

**2**

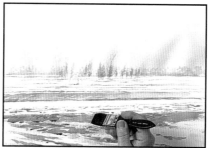

mined by the very shape of the earth. Also, consider the distances between each of the planes, the weather and the way in which the rays of sunlight strike the land.

Fig. 2. Once you have positioned the main elements that define the landscape you are going to paint, spread a tenuous, almost transparent, ultrama-

**3**

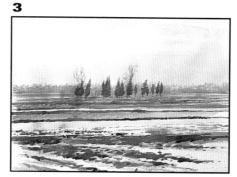

**0**

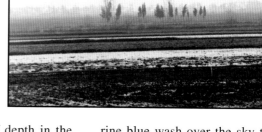

rine blue wash over the sky to completely smother the white of the paper. However, you will see that from the very start the artist leaves the areas in the center of the painting white, just where the strips of frost lie. Color the foreground in such a way that it appears more contrasted to the rest of the painting.

Fig. 3. Keep specifying details in the foreground. Darken the furrow lines in the soil with sepia and Payne's gray. In a recently plowed field, the earth is always slightly darker than normal, and as it goes up and down, you should think about putting in shadows. This color would be far lighter if the land were not cultivated, or if it were seen from a longer distance. With a cinnabar green wash, paint the foliage in the cluster of trees, and then use cadmium green to paint the fields in the distance. Make sure that you dilute the colors heavily to represent the discoloring that occurs when they are seen from afar.

Fig. 4. With the same wash that you used to cover the sky, paint the frost. The only reason for doing this is to take some of the brightness out of the white of the paper, because as the painting has developed, problems with excessive contrast have started arising. To get that lumpy effect of wet soil, the artist superimposes different intensity strokes that contrast in tone. The best way of doing this involves waiting until the previous colors are dry to stop them blending with each other on too wet

**4**

a surface.

Fig. 5. Work on the watercolor as a whole and not in parts. This means that if the foreground is intensified then the same should happen to the vegetation in the background. Therefore, take a small brush and detail the form of the trees with permanent green washes. With burnt umber, use your brush to draw the leafless branches that stick out. The fore-

**6**

ground and middle ground also need to be more detailed, and this is done by painting the texture of the plowed soil with more saturated colors.

Fig. 6. If we look at the finished painting, we see that the objectives, which were the representation of ice and the portrayal of distance and

**5**

width, have been achieved by leaving spaces that describe the frost, given that white is not normally used for watercolor painting. As things get farther away, they gradually get more discolored, so that the horizon appears as a gray mist that contrasts with the intense colors of the field in the foreground. The painting is a good example of

how versatile watercolors can be, combining the accuracy of detail with the looser, more flowing effect of watercolors.

## MODELS

**1**

1-. *Thawing ice at Vétheuil* by Claude Monet (Thyssen-Bornemisza Museum, Madrid). You should never believe that ice is purely white. This painting by Monet shows us that it contains an infinity of colors and different tones, ranging from the sky blue in the snowy mountains in the background to the Naples yellow of the ice floes in the foreground. Ice can also include endless hues of ochre, green and gray.

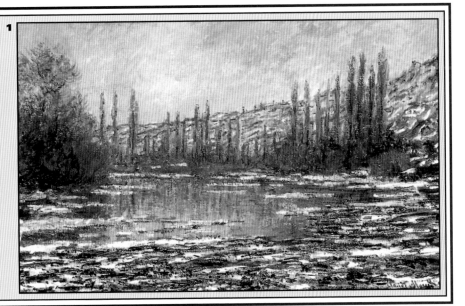

# Snow

How do you paint a snow scene? How do you deal with colors when white is so omnipresent? It is actually quite a simple matter, and one that this next exercise examines. We are going to learn how to create snow effects, and you are going to have to forget any inhibitions you may feel towards the use of color and forget the idea that snow always has to be white. I shall show you that that simply is not true. The subject I have chosen for this exercise is this view of a path in a wood covered by snow in a national park in Spain called Aigües-Tortes (fig. 0).

**1**

The artist, painter and sculptor, Carlant is going to paint it with oils. Pay careful attention because this is a particularly interesting exercise.

Fig. 1. With a number 2 pencil in hand, the artist paints the model with a linear sketch, without forgetting a few important details. Then this preparatory sketch is worked over with a mixture of cobalt blue and a touch of carmine on the artist's brush. It is a good idea to dilute the mixture in a little thinners.

Fig. 2. You need to start with the widest areas, in this case the sky, so as to fill in the areas of white, getting rid of the strength and influence of the white of the canvas as soon as possible. So take a medium brush and cover the sky with a mixture of cobalt blue and titanium white. With the same color mixed with a touch of carmine and ochre, you will get a gray-violet that will come in extremely handy for painting the shadowed parts of the sharp peak in the background. Apply the color in large strokes, avoiding the use of molded or directional lines.

Fig. 3. Apply a soft, pink wash to the snowy side of the mountain and new gray touches to describe the cluster of trees around the foot

**0**

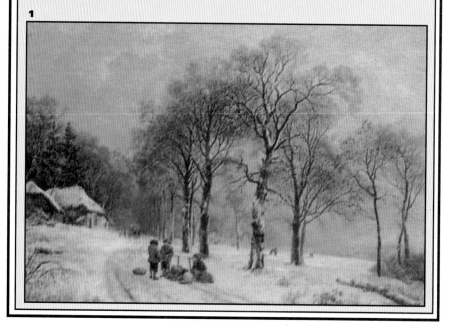

## MODELS

1-. *Winter landscape* by Barend Koekkoek (Rijksmuseum, Amsterdam). Snowfalls completely change our perception of a landscape. Greens and ochre disappear, and the landscape is inundated by a dominance of cool colors that affect the color of the sky and snow. Trees and shrubs, meanwhile, appear to have more defined outlines. They are clearer and darker in color.

**1**

**2**

of the mountain. We continue with the darkest areas of shadow, adjusting the color better and contrasting them to the rest of the painting, but as these are among the vegetation in the foreground, which demand more precision and detail, you should use a smaller and rounder brush. With a mixture of permanent green, burnt umber and ochre, paint the branches of the firtrees to the left of the path.

Fig. 4. Go back to the background. Finishing painting the snow that covers the mountains. As you can see, this is not painted in white, but by a series of degraded, merging grays. The same occurs with the snow in the foreground, although the colors are more intense and the strokes are thicker and pastier. To paint the lumps of snow in the foreground it is best to use a flat, horsehair brush

**3**

and to apply the color with short strokes that are gradually overlapped to form a more homogenous mass. The blue and violet tones should include a few minimal tonal varieties, without too much contrast.

Fig. 5. The artist returns to the background to paint the sloped side of the mountain a little more. With the medium brush, he applies little touches of cyan blue and violet to the shadowed parts of the mountainside. These should be vertical to help suggest the steepness of the mountain. The base of the mountain is painted with blurred gray-violet effects and short strokes applied with the same violet that was used for the peak. The foreground gradually starts appearing, in particular the group of trees on the

**3**

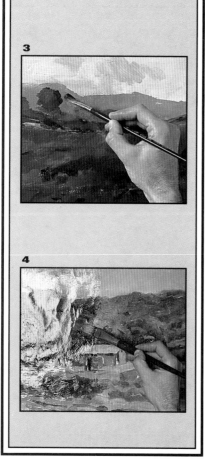

**4**

**4**

cise strokes of permanent green, gray, ochre and burnt umber. These colors merge on the support and create turbid colors that contrast with the other purer, cleaner colors that were used to paint the snow. The opaque color of the vegetation darkens the general tones of the image, but thanks to the spaces that let the color beneath show through, the surface looks bright enough.

Fig. 7. You have probably noticed that the artist has not yet even touched any white paint. Now is the time, and he uses it to blur and blend

right. The artist has colored the tree-trunk with burnt umber and some of the branches with permanent green. Rather than being too detailed, the trees could best be described as sketchy. Notice how the artist has not painted the whole tree, he has left it to the white of the support to show the strip of white that goes from the top to the bottom of the trunk. This clearly shows which parts of the bark are illuminated and which are not.

Fig. 6. The artist paints the foliage in the cluster of firtrees on the right in a blurry way. He has scribbled impre-

**5**

colors, and to make the transitions between colors softer and brighter. To begin with, he adds specks of white to the violet in the foreground to soften the contrasts with the rest of the painting. He spreads paint over the space where the white of the support is still visible, although as you can see he does not cover it completely. Likewise, he adds a few soft mixtures of cyan blue and white to the branches of the trees on the right, thus simulating the snow that has landed upon them.

Fig. 8. In the foreground, the contrasts between the different shades of blue have been soft-

**6**

**7**

**8**

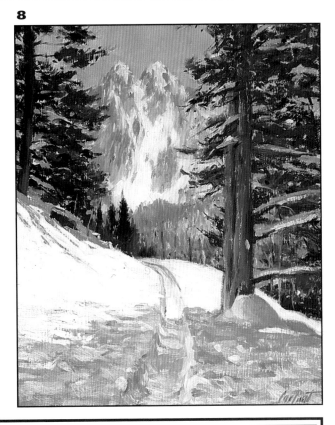

ened; a few colors have been blended together, producing gradations in tone and color. Light blue has been applied to the top of the mountain to integrate it better with the color of the sky. These subtle effects with such wintry colors are beautifully combined in the painting. See how carefully orchestrated all of the different greenish-blues, violets and touches of white are. This should be all of the inspiration you need to go out and paint your own snowscapes, bearing in mind everything that you have learned on these pages.

# MODELS

2-. *Barges in the snow* by Guillaumin (Bonnat Museum, Bayonne). This snow has been painted with directional, expressive lines with the dry brush technique. Notice the presence of violets, ochres and tenuous blues in the white of the snow, which manages to mold the flashes of color produced by the light as it strikes the different features of the landscape.

**2**

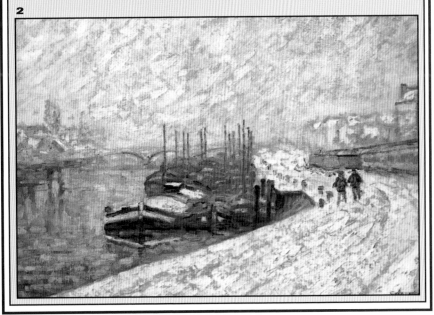

# Painting a snowstorm

With Carlant, we have seen how to paint a snow scene with oil paints, and now with Ester Llaudet we will learn how to paint an alpine scene during a heavy snowfall with pastels and watercolors. The main difference between this and the previous exercise is that, rather than painting the snow, we are going to leave the white of the paper blank. As you know, white is hardly ever used in watercolor painting.

Fig. 1. The artist starts with a tenuous linear drawing that positions the main features of the composition. In almost no time at all he takes a medium, round sable brush and applies the first washes. With raw sienna she

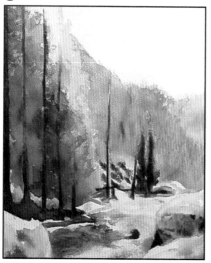

paints the tree-trunks and with a mixture of Payne's gray, ochre and more sienna she paints the trees. Paint on wet to get the effect of the water in the stream that flows through the foreground.

Fig. 2. Ester Llaudet works wet on wet as she completes the basic composition, letting her colors mix together and form degradations and interesting transitions of color. Paint the vegetation to the left of the painting with a mixture of ultramarine blue, emerald green, ochre and burnt umber. These should

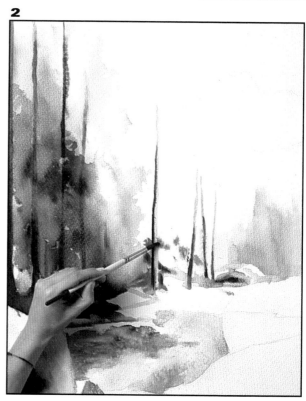

## MODELS

1-. *Snowstorm* by William Turner (Tate Gallery, London). In this painting of a snowstorm at sea painted by Turner, we can see how interested the artist was in vigorous lines made with a dry brush. The snow and strong wind are blended by hundreds of lines and parabolas that the surface of the painting describes. This is an extremely dramatic technique.

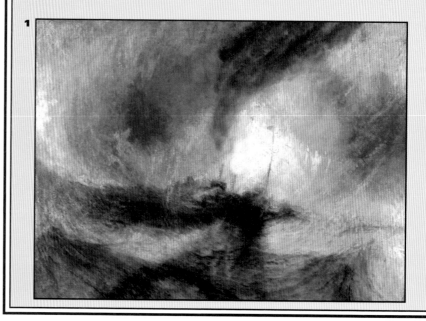

**4**

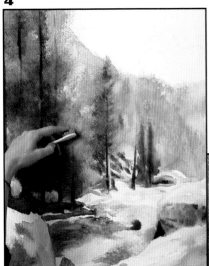

get gradually lighter and have more diffused edges as they get farther away.

Fig. 3. With a burnt umber wash, paint the rock in the foreground. Notice how the artist does not use uniform washes but distributes the particles of paint irregularly to form tiny lumps. With a large brush, paint the outline of the mountains with semitransparent washes of emerald green and ultramarine blue, both colors somewhat dirtied with burnt umber. With successive brown washes, she has modified the colors of the leaves of the firtrees on the right.

Fig. 4. The artist takes an old toothbrush and flicks cadmium green and permanent green onto the branches of the trees. Landscape painters often use splattering techniques to represent the disintegrated appearance of leaves. It is an excellent way of suggesting certain textures, and is also used to brighten up areas of plain color.

**5**

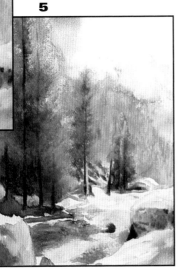

Fig. 5. With a little very diluted ochre, paint the peak that rises in the background. Spread cobalt blue over the top of the paper to suggest the first signs of the sky. The artist has applied a few more flicks of paint to suggest the thick, green appearance of the group of trees. At this point, you should leave the watercolor to dry for about twenty minutes before applying the snowflakes with pastels.

Fig. 6. Take a white or light beige pastel stick (the latter would be preferable). Holding the stick longways, rub the background of the composition so that it looks whiter. Now use your fingers to blur the forms a little more. Now use the point of the stick to apply pointillism to the whole surface, making sure that it is not too uniform. In other words, try to avoid the snowflakes being the same distance apart or always being the same size. When you have finished adding the dots, you can sign your work and consider it finished.

**6**

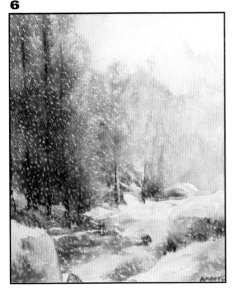

## TIPS

1-. Keep changing your water or it will dirty your colors, and always keep the colors on your palette clean.

2-. This flicking technique, called aspersion, will help you create new textures and produce a granulated effect on the painting surface. To do this, find an old toothbrush, dip it in a watery watercolor and flick it onto the surface of the painting by combining the top of the bristles with a fingernail.

**1**

**2**

# Glossary

**A**

**Agglutinate.** Substance that is mixed with powdered pigment to make a medium of painting.

*Alla prima.* Direct painting technique that involves painting quickly in just one session and never going back over what one has painted.

**B**

**Blending.** Procedure that involves softening contours and areas of contact between colors to form gentle gradations.

**C**

**Chiaroscuro.** Rembrandt was a master of chiaroscuro. In his work, forms and colors are clearly visible despite being surrounded by intense shadows. In his books on painting, Parramón defines chiaroscuro as "the art of painting light over shadow".

**Chromatic harmony.** The balanced relationship of different colors within a painting.

**Composition.** The balanced and harmonized distribution of the different elements that appear in a picture. Composing involves bearing these factors in mind as one selects the best arrangements.

**Covering capacity.** The capacity that a color has to dominate other colors in mixtures and veils.

**D**

**Degradation.** Reducing the value of a tone, gradually making it more intense or softer, so that the transition is gradual rather than abrupt.

**Dry brush.** Painting technique that involves applying thick paint to the support, so that it sticks to both the pores in the canvas and the texture of the paint on the surface.

**F**

**Film.** Layer of paint or coating over the surface.

**Fit.** Preliminary drawing that establishes the basic structure of bodies as simple geometric forms (cubes, rectangles, prisms etc) that are often known as frames.

**G**

**Genre.** Classification of artistic techniques, such as still lives, landscapes, figures and interiors.

**Graffito.** Technique that involves scraping a layer of color with a sharp instrument, so that the color of the support becomes visible.

**I**

**Induction of complementaries.** A phenomenon derived from simultaneous contrasts, which complies with the norm that states that "to modify a particular color, you simply need to change the color that surrounds it".

**L**

**Local color.** The genuine color of an object when it is not affected by shadow, reflections or other factors.

**M**

**Medium.** Liquid in which pigments are held, for example linseed oil is used for oil paints and acrylic resin for acrylics. Pastel sticks can be mixed or dampened in any of these mediums.

**Merging.** Technique that involves spreading or reducing one or more layers of color onto to a background layer, so that the lower layer is still visible through the superimposed one.

**Mixed techniques.** Using different painting procedures in the same picture, or using a combination of different supports.

**Modeling.** Although this is a sculptural term, it can also be applied to painting and drawing to refer to the way in which different tones are applied to create an illusion of the third dimension.

**O**

**Opacity.** The capacity that a gray shade or wash has for covering a layer below it. Opacity varies from pigment to pigment.

**Opaque painting technique.** Pastel technique that involves applying thick layers of color to create a textured surface with little or no merging.

**P**

**Pasting.** Technique that involves applying thick layers of color to create textured surfaces.

**Perspective.** Way of representing the three-dimensional world on a two-dimensional surface.

**Pigments.** Coloring agents in powdered form that are obtained from natural sources (although some are now made synthetically) that, when mixed with an agglutinate, create paint.

**Pointillism.** Painting technique that involves applying small dots to the canvas.

**Pre-painting.** Preliminary paint that the rest of the colors of a piece are painted over.

**Preparatory sketch.** The preliminary stage in the construction of a drawing or painting, from which the definitive piece can be derived. Several sketches might be made before the artist decides upon the idea he wants to work with.

**Primer.** Adhesive or gelatinous material that is applied to the canvas before it is painted, making the support less absorbent. It can also be used as an agglutinate in paint.

**Proportion.** The relationship of one part with the tonality of a piece.

# S

**Saturation.** Value or chromatic degree of a color. Strength of a color that a surface can reflect.

**Solvents.** Liquids used for dissolving oil paints. The solvent for water based colors is water and for oil based products, turpentine essence, thinners and similar substances are used.

**Stanley Knife.** Sharp knife used for cutting paper, made up of a metal blade inside a plastic handle.

**Style.** In sculpture, drawing and painting, this is the way that the task is approached. It can be agitated, brusque, delicate, slow, fast... It determines the manner of working of each individual artist.

**Support.** Surface used for painting or drawing, such a board, sheet of paper or canvas.

# T

**Texture.** Tactile and visual quality of the surface of a drawing or painting. It can be smooth, granulated, rough or cracked.

**Tonal background.** Opaque coloring in which the color is mixed with white to spread the color in a uniform way. A tonal background can also be colored.

Tonal color. Color offered by the shadow of objects.

**Tone.** Term that has its origins in music that, when applied to art, refers to the strength and relief of all the parts of a painting with respect to light and color.

**Transparency.** Way of applying color so that light or the previous layer of color filters through.

# V

**Value.** As much in drawing as painting, volume or modeling is obtained from the tonal values of the model. At the same time, it is achieved through the comparison and tonal resolution of effects of light and shadow.

**Veils.** Layers of transparent color that are superimposed over the preliminary color when it is dry.

**Viscosity.** Measure of the characteristic fluidity of a color or medium.

Volatility. Evaporation potential of a solution.

**Volume.** Three-dimensional effect of a model in the two-dimensional space of a painting.

# W

**Wet on wet painting.** Technique that involves painting over an area of recently applied paint while it is still damp. The level of dampness can be controlled, depending on the effect that the artist wishes to create.

**Whiting.** Ground, washed chalk that is used for priming cloth and in the composition of pastels.

# Acknowledgements

The author would like to thank the following people and companies for their help in publishing this volume of the Effects and tricks series. Gabriel Martín Roig for helping with the writing and the general coordination of the book; Antonio Oromí for his photography; Vicenç Piera of the Piera company for advice and orientation concerning painting and drawing materials and utensils; Manel Úbeda of the Novasis company for their help with the edition and production of the photosetting and photostatting; Olga Bernard, Bibiana Crespo, Amin Idrissi, Carlant, Óscar Sanchís and Eva M.ª Durán for granting us permission to use several photographs that were used as models for painting, and a special thanks to the artists Carlant, Josep Antoni Domingo, Antoni Messeguer, Óscar Sanchís and Ester Llaudet.